THE ENTREPRENEURIAL PARENT

RUN YOUR BUSINESS, RAISE YOUR FAMILY, KEEP YOUR SANITY!

CHANDRA CLARKE

TERENCE JOHNSON

OBSIDIAN OWL
PRESS

ISBN (paperback): 978-1-7772174-2-6
ISBN (ebook): 978-1-7772174-3-3

CONTENTS

It was a miserably hot and sticky July afternoon.

Earlier that day, we had discovered that our house, a triplex located in a not-so-good part of town, needed an expensive repair and that one of our tenants upstairs wasn't going to make her rent payment ... again.

We had been putting eighteen-hour days into our business, and our nights were completely given over to the demands of our firstborn son. Just one month old, he wouldn't sleep for more than forty-five minutes at a time, had a voracious appetite, and was developing a terrible case of colic.

And the house—our office—was a complete mess.

So, of course, it happened.

Just moments after getting him settled—at long, *long* last— and sitting down at the desk to deal with some desperately

urgent customer service issue, our baby started up again. Our sweet, innocent, gorgeous little gift of a boy wailed ...

... And Chandra *yelled* in frustration.

Naturally, Terry then yelled at Chandra to knock it off. He was short on sleep, was trying to work on some programming bug, and she had just shouted, startling an already upset baby.

We both stared at each other, aghast, for a long time.

This was *not* how things were supposed to be.

Was it?

The media would have you believe a lot of things about being an entrepreneur.

If you're under thirty, you have probably come to believe that it involves hoodies and all-night whiteboard scribbling sessions and espresso-fuelled coding marathons. A few months of ramen noodles and then *presto-bingo!* Growth hacking. Scaling. VC funding. A multi-million dollar acquisition.

If you're over thirty, well, there's always the Richard Branson model. Jet planes and private islands. Corporate takeovers and really good scotch. Motorbikes and mansions. Ooh, and government bailouts!

Entrepreneurialism has become a *lifestyle*. The word *freedom* gets tossed around a lot.

All the cool kids want to do it.

Parenthood looks pretty shiny and awesome from afar too.

Motherhood is all about being perfectly made up and coiffed, gazing down adoringly at your angelic little tot in the early morning light. And fatherhood is clearly all about having heart-to-heart talks with your preteens, out in the fresh autumn air, while raking the leaves and smiling. There's usually a sweet dog boinging around in the background too.

Facebook. TikTok. Instagram. Or whatever is currently hot as you're reading this. These sites don't help matters much when it comes to perceptions versus real life.

I just had an AMAZING dinner at Rocky's. The dry-aged steak was out of this world!

#grateful #ballin'

Gorgeous celebrity-grade photos of perfect weddings.

So proud of Sarah! A+ on her math exam. Loving life right now!

Yeah man! Just cleared my inbox to ZERO and am OUTTA here for a week in Maui and two weeks in Greece!

Sepia-filtered shots of urban tourist attractions. A sidebar filled with ads about banking a million bucks with no effort. Passive income, baby!

Everyone seems to have it all together ... while there you sit at a desk littered with bills and Lego® pieces and baby bottles and wondering if you can put in Just. One. More. Hour ... before crawling into bed.

The reality is that starting a business and making it a success is one of the most challenging things you can do, career-wise. Meanwhile, having children and raising a family is one of the most difficult things you can do personally. So it would be absolutely insane to try to both at once, right?

But thousands of us do, every single day.

Some of us even do this as single parents, or with special-needs kids, or with ailing parents. Or all of the above! It's tough; no, wait ... it's exhausting. But—and here's where it gets *really* crazy—even with all the blood, sweat, and tears, the guilt and the doubt, you wouldn't have it any other way, would you?

No, we didn't think so. And neither would we.

That's why we wrote this book. We wrote it for you, the unsung heroes of the business world, who are out there on the front lines, following your dreams and passions. You're the ones out there trying to get it done *and* do right by your family.

We want to show you that it *is* possible to do both and still maintain your sanity.

WHO ARE WE?

WE ARE Terence Johnson and Chandra Clarke, and boy, do we know what it's like down in the trenches.

We founded Scribendi.com, a company we built from a basement startup up to be the world's largest and most respected editing and proofreading services firm. When it was acquired,[1] Scribendi had staff in nearly every country worldwide and had provided English language document revision to customers in more than 100 countries. It was a Profit500[2] company a number of times, and Chandra was in the Profit W100[3] for several consecutive years.

After a sabbatical of sorts, we moved on to round two of our entrepreneurial career. We currently own an education platform that provides courses in writing, editing, and proofreading; the small press Tiger Maple Publishing that produced this very book; a board games café and indepen-

dent bookstore called Turns and Tales; and a number of other ventures and investments.

On the family side, we have four children and two dogs. As we write this, our kids range in age from teenager (uh-oh!) down to third grader. We homeschooled our kids while running Scribendi, and of course we also ferried them to all the extracurricular stuff you might expect, like soccer practice, swimming lessons, karate, Scouts, and piano class. We still do.

We volunteer, too. Our commitments have changed over the years, but right now, Terry is the president of a national charity pushing to get better public transportation infrastructure in our country, is heavily involved in provincial and federal politics, and sits on a local housing board. Chandra served as chair of her local library board until just recently, found time to complete a PhD, and is currently involved in environmental activism.

Now, if you have been the victim of a few of those stupid clickbait articles promising to tell you how *Guru X did Amazing Thing Y!*, you're likely waiting for the other shoe to drop. You know, that throwaway line that reveals that Guru X had some sort of advantage, like a huge inheritance, that you can't hope to duplicate. So let's address that concern before we get any further.

We fully acknowledge that we owe a big debt to our respective backgrounds. We both came from aspirational families that had worked their way up to lower middle-class comfort by the time we were teenagers. Both of us

had gotten our undergraduate degrees[4] and had some work experience before starting our business, so we had the comfort of knowing we could *probably* find employment if things went bad. We definitely recognize that we benefited from our ethnic heritage (white) in a society that still, stupidly and systemically, privileges such a thing. (Terry is an immigrant, but the toughest adjustment he had to make in his new country was learning how to ice skate.) We should also note that we are fortunate enough to live in a politically stable country with universal health care.

What we didn't have, unlike those article gurus, is any startup capital or seed funding. No big savings accounts to draw on. No credit cards to max out. Nor did we have any mentors, support networks, or formal business training. Also, cross out government support and bank loans until much, much later in our entrepreneurial journey.

We certainly couldn't afford babysitters or nannies, and we lived too far away from family members to get much tot-minding. Terry's family did what they could to help us from afar by sending baby gear and lots of encouragement, while Chandra's parents mostly thought we were nuts.

We tell you all of this not to brag (well, okay, maybe a little), but let you know where we're coming from. We know exactly how hard it is to manage staff while you've got a teething tot waking you up every few hours.

We've faced the same decisions you've faced: upgrade the computer or buy the bed you need to replace the crib? Repair the @#$%^! dishwasher that has broken (again!) or

crank through the three hundred emails that have piled up in the last half-day?

We've seen it all ... And we've now come to a place where we're happy, healthy, and we even have time for *hobbies*. You remember those, right?

So now we want to help you get to that same sweet spot. And with any luck, reading this book will help you get there faster.

1. Yes, acquired. We have been through every phase in the modern entrepreneur's life. More on this later!
2. A nationwide ranking of Canada's top growth companies.
3. A nationwide ranking of Canada's top-one-hundred female entrepreneurs.
4. This is somewhat tempered by the fact that those degrees also came with a large chunk of student debt.

DO NOT SKIP THIS CHAPTER

THIS IS the bit where we tell you how to use this book. Why shouldn't you skip it?

More than anything else, we've written this book so you *look at where you've been* and *fix what you missed*. And so that you can *peer into the future and avoid the same issues and pain we went through.*

We know that you will be really, really tempted to jump to the section that you think most applies to where you think you are with your business, and read *only* that section right now. After all, you wouldn't be an entrepreneur if you weren't looking to cut to the chase and move on, right?

Do not do this. Instead, *read the whole book*—cover to cover.

While you might already be in the Grind or Plateau phase of your business (more below), you might be stuck there

precisely because you haven't addressed something we note in a previous phase. Or maybe you're just starting out and you figure you'll read the other sections, eventually, when you get there.

Don't do this either.

For one thing, you'll forget to come back to the book. Life, with a capital L, will happen. Or you won't recognize that you've moved to the next phase, or maybe your dog will chew up your copy before you can get to it. (In which case, go ahead and buy another copy, we won't mind!)

As we said, more than anything else, we've written this book so you can *look at where you've been* and *fix what you missed*. And so that you can *peer into the future and avoid the same issues and pain we went through*.

Invest the time now, and it will pay off big time for you again and again.

Indeed, this is so important, we'll say it again: *read the whole book*—cover to cover.

Seriously, we mean it!

THE SECRETS WE SHARE

In order to make this as timeless and as useful as possible, we've done two things.

First, we've organized the book by the business phases you're almost certainly going to go (or have gone) through:

The Startup Phase, The Grind, The Plateau, The Happy Hill, and *The Exit.*

Second, in all cases, we've provided both theory *and* practice, with a stronger emphasis on the theory part. What do we mean by that?

Too often, as entrepreneurs, we read about how *Bigshot Entrepreneur A* used *Fancy Tool B* to skyrocket his or her business, and we think, "Woohoo! That's the silver bullet!" and we invest a ton of time and money into adopting that tool ... only to be disappointed in the results. Why? Because while that tool might have worked for that entrepreneur at that particular time, it might not be the right tool for *your* situation. The same can be said for parenting advice. The temper-tantrum calming method used by the moms in the magazines might be completely ineffective for your kidlet. This is why so much "business advice" fails to produce results.

In this book, we spend much more time on the theory or the principle or the issue, or whatever you want to call it, so you can get to the root cause of your woes.

But don't worry: we know that, caveats aside, *everyone* loves a good tool recommendation or hack, so we've included them wherever possible. Just regard them as suggestions or jumping-off points, rather than iron-clad commandments. Take the time to evaluate what they do and whether they'll work for your situation. Speaking of which...

UH, WILL THERE BE HOMEWORK?

Early readers of this book all one bit of feedback in common: a companion workbook would be *awesome*.

So, we made one. It's completely optional; you'll get tons of value from this book all on its own, and when you're inspired by ideas and thoughts as you read, you can always just jot them down in a regular notebook.

The workbook provides a structure for your notes that follows this book and includes a bonus resources section.

https://tigermaplepublishing.com/entrepreneur-book/

THE STARTUP PHASE

PERHAPS IT BEGAN with an inspired *Aha!* in the shower or on the commute home one day. Or maybe it was a less inspiring, rough start: a job loss, a spouse or partner's sudden departure, one-snark-too-many from that jerk of a boss.

One way or the other, there's nothing quite so exhilarating as the Startup phase of a business.

And there's nothing quite so freakin' scary either.

In many ways, starting a business is almost exactly like starting a family. The future is one big uncertain question mark, but that's kind of exciting. Your business, just like your new baby, represents hope and horizons and endless possibilities. It also means lots of soul-searching, inevitably at 3 a.m., when you realize, *Oh my gosh, I'm the boss now.* The buck stops with *me.* It's exactly like that moment

when you look down at your teeny child and realize, *There's a* life *in my hands. I'm a parent now.*

Holy crap.

Indeed, the two things are so alike, many people tend to think of their businesses as "another baby." It's not a bad way to conceptualize it, as there are lots of obvious parallels.

And this begs the question: If there are so many similarities, are there any overarching principles that will guide us through the rough bits of both a startup business and startup family?

The answer is yes. Let's dive into those first.

GETTING CLARITY. ON EVERYTHING.

 The best way to predict the future is to create it.

– Alan Kay

One of the unfortunate realities of life is that no one knows exactly how it will unfold. We can't say exactly what traffic will be like on Saturday, and we don't know whether our next child will be a girl or a boy.

That doesn't mean the future needs to be completely cloudy. We can make a lot of educated guesses based on our current information. For instance, we can say that traffic will probably be less bad on Saturday morning than it will be on Friday at 5 p.m. If we know that twins have run in our family for six generations, there's a good chance we'll have twins too.

More importantly, we can impose at least a little control on our future by creating a clear vision of what we want out of it. Success, especially repeatable success, rarely happens by accident. To really make it happen, you have to figure out exactly what you want and when you want it to happen. That takes planning.

No! We hear you howl. Not the dreaded business plan! That's such a drag! And what about all of those business owners we keep reading about that admit they didn't have one?

Well, first (and we'll keep coming back to this point in this book because it's so important), the business people you see interviewed in the press *are some of the few who actually made it.* No one wants to interview the people who crashed and burned. The hard truth is that the majority of businesses fail in their very first year of operation[1] ... and most of these failures will be because they didn't have a plan. Or worse, they made up a plan without having done any homework, or made up a plan "for the bank" and then didn't follow it once they'd secured financing.

You do not want to be one of these stats!

Second, these particular success stories get the interviews because they're unusual. No one ever interviews the people who wrote a business plan, stuck to it, and gradually made it to the top, because that doesn't make good copy for the media outlet. Mavericks! Rogues! Those are the people who get the headlines. That's not a bad thing, but you need to remember these are outliers.

Third, it's important to remember that a lot of entrepreneur success stories might be exaggerated for dramatic effect. This is not to say that these entrepreneurs are fibbing, buuut ... let's just say that, knowing as they do that the way to get good press is to have an interesting story, obviously they're going to emphasize the interesting bits and de-emphasize or even completely omit the boring parts.

Have you ever noticed how many entrepreneurs supposedly started their business in their garage or basement? Or

claim to have sold candy (or baseball cards or comic books or ...) to other kids as youngsters, and thus have always "naturally" been business experts? Or they immigrated to their current country and were always on the hustle, getting their first paper route at age six, and had a complete magazine stand by age twelve?[2] Maybe they did, maybe they didn't. The important thing for you to realize is that this is the storytelling aspect that's part of good marketing and that you should take it with a big ol' grain of salt ... even as you make notes on how they frame their backstory!

To be successful, you really do need a plan. Not just any old plan either: you want one that has very specific goals and a timeline. You want to be very clear about exactly what you want to accomplish and by what date.

Why?

Without a specific deadline for your goals, you're basically *hoping* that they will happen ... someday. You might eventually get there, but you're going to get there a lot faster if you have a deadline staring you in the face.

Without a detailed goal in mind, you'll waste a lot of time floundering around, hoping for good things to happen. With a specific objective, you'll be able to walk it backward to determine the steps you need to get there.

For example, it's not even enough to say, "I want to make a million dollars within the next five years." You need to say, "I want to make a million dollars *in profit* from the sale of my purple widgets by the end of year X."

By being so detailed, you now know that you have to have the production capacity to produce X number of purple widgets, you have to advertise the availability of the purple widgets, and you know you have to work out the costs and margins for your widgets. You also know how much you have to sell, and by when.

What We Did

It was 2007, and it was darned cold outside. We stumbled out into the bright sun and looked at each other, shell-shocked, as our breath made white plumes in the air.

We had just been through a ridiculously intense afternoon that had felt more like an interrogation than a consulting session. We had an hour-long drive home ahead of us, and after that, what would likely amount to (another) night of broken sleep as our second son was teething.

True confession time: We did not have a plan for our business. At least not at the beginning. Chandra had started out by taking in a few freelance editing jobs, realized there was a pretty big market for what she was doing, and things took off from there.

We muddled along for quite a while, making small gains here and there through trial and error. This was also when we were newly married, new parents, and new homeowners. We now refer to this period as The Bad Old Days—days of exhaustion, crazy stressful days, and down days outnumbering the good days by a wide margin.

We were doing fairly well, but we knew we had to do better because the personal cost was way too high. We were working hard, but we weren't working *smart*. It was then that Terry insisted we hire a consultant and developed a proper plan.

The consulting process itself was beyond tiring. It consisted of several half-days over a period of a few weeks of laser-focused review of our business, our processes, our ambitions, and most of all, our assumptions. It was also a very expensive process. At the end of it all, we had a solid plan for action.

But we had come to it the hard way.

Interestingly, the thing we had *thought* we needed to do next—namely, hire salespeople—was actually the last thing we needed to do. The consultant rightly counselled us to get support staff (so, bookkeeping, customer service, HR) in place for the business so we could "take off those hats" and focus on what we did best: big ideas, planning, and leadership.

Sigh ... How much better would it have been if we had *started* with a plan?

We were much more organized about our family life from the get-go. We knew we wanted four children; we also knew that because Chandra was thirty when we got married, we didn't want to wait too long to get started. We wanted at least a little space between each diaper and teething phase, so this meant having a child every two

years. The age gaps weren't as precise as that in the end, but we were extremely fortunate to see this work out roughly the way we wanted it to.

What You Can Do

The toughest part of writing a business plan is knowing what to put into it. If you've never run a business before, how can you possibly figure out the best questions to ask yourself to reach your goals?

Luckily, there are dozens of (free!) resources available. If templates are your thing, you can find several freebies just by using a search engine.[3] If you prefer a software/wizard type approach, where you're guided (tricked?) into making a plan by answering questions, that's an option too. (We've also included a business plan template in the companion workbook.) Make sure you pick one that asks you to assess your business environment for threats and opportunities, especially if your business idea centres on intellectual property. You may find that what you're doing has already been patented or that the business name you want is trademarked.

What if you've already started your business? Well, you'll have worked out at least some details the hard way, so you'll be able to make much better predictions. But don't assume that since you've made it this far, you can continue winging it. Taking the time to create a business plan for the next year and for the next five years is a fantastic, high return on your time investment.

It *will* make your life much easier.

Another really good exercise is to create what's called a vision board or a vision wall. This is where you find pictures that represent (as closely as possible) what you want to have or create and pin them up on a dedicated space where you're going to see them every day. The value here is that it forces you to think really hard about *exactly* what you want to achieve because you have to figure out what that looks like to you. This applies to both your business and personal life.

For example, perhaps you've always dreamed about owning a three-bedroom house with a huge yard in the country. Not only will it be fun to go virtual house shopping to look for pictures, but it might also make you realize that you live in the wrong place to make that happen. Or perhaps you'll discover that no, in fact, condo life suits you just fine, that what you really want is access to a top-of-the-line fitness facility. Again, clarity is key. You won't be able to work out how to get to where you want to be if you don't have the coordinates.

A vision wall for your business will also be very helpful to your staff, when you get them. It will help you communicate your grand plan for the business and give them an idea of where they might fit in the big picture.

Indeed, it's critical that your vision board be *physical*, not digital, and somewhere where you (and your staff) will see it. Why? Digital still feels like a dream, and it's just too easy to lose track of a file or a URL as the day-to-day stuff

piles up. So do actually use pictures and a real wall! As a bonus, when you actually achieve some of those visions, you can move those images to a trophy board. You can also adjust your vision board over time if your goals change and as you rack up successes.

Fun true story: In a recent spring cleaning, we found one of our original vision boards, made back when we were living in that house[4] we mentioned in the intro. We were delighted to discover that our current home was nearly identical to the one we'd dreamed about back then, even though we'd kind of forgotten about that first board!

In the workbook we've mentioned, we've provided some ideas and examples to help you get started.

BEGIN AS YOU MEAN TO CARRY ON

 The beginning is the most important part of the work.

-- Plato

Humans are creatures of habit.

We have to be. Every day we're faced with hundreds of little choices. Like, do I brush my teeth first or have a shower? Should I take Calder Avenue to get to the store or Mitchell Street? Do I want cream or milk in my coffee? Habits allow us to breeze through the less important parts of our day without getting bogged down in the details.

The problem with habits and routines is that we're so good at them, we quite often form them without even realizing. Even worse, because we don't think much about our routines, they can end up being counterproductive after a while.

That's why it's so important to *start well*.

In business, a good example of this is bookkeeping. It's so, so easy to put stuff down "temporarily" and think, "Oh, I'll get to that later." A couple of receipts get shoved in a drawer, a few invoices are tossed in the in-basket, and so on. Then, when it's time to actually do the books at month end, your desk is a trash heap, you're scrambling to find everything you need, you're overwhelmed, and it takes six times the time to untangle it all.

In your family, little children are absolute masters at setting up increasingly unhelpful habits, especially at night. It starts with a 2 a.m. call for a glass of water. Then again the next night, only this time Mummy or Daddy *must* sit on the side of the bed while the water is drunk. Then there's a bit of conversation, perhaps a request for another bedtime story. Then there's the special tucking-in process, and before you know it, two weeks later it's routinely 3.30 a.m. before you can stagger back to bed. Ugh.

You can—just about—fly by the seat of your pants like this when you only have a few clients or only one child. But things will fall apart pretty rapidly as your family and business grow.

Separate Corners, Please

The most important thing to start well? Your business and your personal finances, and your business and your personal legal situations, need to be kept separate.

Very, very separate.

Like, right now.

We know it's hard, at this stage, especially if you're doing things like financing your startup out of your savings or through personal loans from friends, or worse, credit cards. But the sooner you start doing this cleanly, the better off you'll be.

For one thing, it's a lot of work (which will cost you either time or money) to fix this kind of thing later on. The longer you leave your finances comingled, the worse it gets.

For another, it's a major risk. If something goes wrong, it's not just your business on the line, but your household as well.

And, dare we say the words? Tax audits. They happen all the time. The harder the auditor has to work to understand your finances, the grouchier they're going to be.

Talk to your bookkeeper about how to do things like entries for shareholder contributions and loans, and get things like separate business bank accounts and business credit cards set up sooner rather than later.

And legally, you will want to create a limited liability company or corporation to separate your personal life from your business life. Talk with a lawyer about this; it's absolutely worth the expense. You'll want to be protected against things like lawsuits, business partnership relationships going wrong, and personal relationship breakups (divorce!), among other things.

Have we frowned at you enough about this? Yes? Okay, let's move on to something much lighter (but just as liable to trip you up!)

The Key to Everything

Chandra finally snapped around the time she'd misplaced her keys for the 153rd time. Coat pocket? No. Purse? No. Desk? No. Kitchen table? Nuh-uh. Wait, what? They're on the bathroom sink? Oy.

She really should have been a professor because then she'd at least fit the stereotype and have a decent excuse for having her head in the clouds and being absent-minded about her stuff. But she wasn't, so having to spend twenty minutes looking for the keys *again* was getting seriously old. Not to mention embarrassing.

Then she discovered the miracle of the key hook.

It's one of those solutions that seems head-smackingly obvious, in retrospect. *Duh*. A place to hang your keys.

More important than the actual key hook, though, is the principle behind it.

She established a new way of carrying on. The keys got a permanent home, she developed the habit of hanging them up as soon as she came into the house, and ninety-five percent of the time she needs her keys, they are where they are supposed to be. (She relapses from time to time.)

Life became infinitely less annoying when this principle was applied elsewhere. All the paperwork that needs filing goes in one bin, and stuff that needs action gets put in another. When someone in the family finishes one of the thirty-odd library books we collectively borrow every couple of weeks, it goes on the table in the hallway so we don't have to play treasure hunt when it's time to return books. There was a schedule for cleaning up the break room at the office, so we didn't waste a lot of time debating about who did it last time. The kids know that if they happen to wake up early, they're *not* allowed to go charging about the house (the mantra is: "get up, get dressed, read quietly").

Does all of this sound a bit, erm, anal-retentive? Don't worry, we have dirty dishes in our kitchen sink … oh, pretty much all the time. And our long-suffering bookkeeper still needs us to chase down our receipts more often than we'd like to admit. But for the most part, the concept has served us very well because as our business and family grew, so did the demands on our time and attention. We're able to handle it all because we cut out a lot of the potential chaos with some strategic organization early on.

How You Can Do It Better

First, take stock of the stuff that is already tripping you up on a regular basis—both figuratively and literally (we're looking at you, Lego® bricks). There are probably at least half a dozen things you end up spinning your wheels on all the time. Think in terms of what constantly frustrates you or exasperates you. What causes kid fussing? What wastes your time? What makes it hard to focus? It might be something as simple as a bad Wi-Fi connection or as (potentially) complicated as a daily toddler meltdown first thing in the morning about what clothes to wear.

Next, figure out *one* thing to try to fix or reduce one problem. For that Wi-Fi issue, this might mean switching internet providers or biting the bullet and upgrading the router. For your toddler, it could be that simply changing up the timing of the clothing question (e.g., laying out clothes the night before) might be enough to bring that nightly fight down to DefCon 1 instead of 5.

Oh, and by the way, your business issues are not unrelated to your childcare issues. Reduce your frustration at the office, and you'll have more brain space (more patience and less guilt) for your kids.

Why just one thing? Simple: *overly complicated fixes rarely get taken up as habits.* Think: a spare sturdy cardboard box to shovel all that Lego® into, not a complete system with six planes of focus, five workflow steps, and eight potential action levels. (With apologies to *Getting Things Done*® fans).

Ideas that might inspire you (and that we use):

1. A dedicated device charging area (or two) that is also surge protected. Especially useful as your kids get old enough for all the tech goodies.
2. A "to do" app (we currently use the paid version of Todoist) that syncs to all your devices and that includes ALL of your to dos—business and home—so they're not in your head. You should also try to use one that you can share with your business and/or life partner. Bonus points if you set the app dashboard as your web browser home page.
3. A shared calendar app, so you and your partner (and your kids!) don't double and triple book the same dates. Remember: *if it's not on the calendar, it doesn't happen.*
4. As we live in Canada and have four kids, hats and mittens were a nightmare until we repurposed one of those shoe organizers that hang on the door. Each kid (and adult!) has a "shoe space" for the hat, and another for a (matching!) pair of mittens/gloves. We even labelled them.
5. Speaking of which, a label printer is *ridiculously* useful.
6. At the office, we didn't have waste bins at each desk because we wanted staff to have an excuse to get up from their largely sedentary tasks and stretch the legs a bit; there was a big bin in the office kitchen/break area. On a related note, some people weren't recycling their waste, even though

we provided bins for it. Our greener staff members found it frustrating to have to fish stuff out of the trash to get it in the right bin. So we "changed the interface." We moved the recycling bins to be nearest to the break room door and put the garbage bin further away. Recycling compliance went up to nearly a hundred percent without having to say a word.

7. Spousal/partner negotiated limits: What decisions can safely be made without spousal/partner consultation? If you have established a level of trust between you, it ought to be possible to say, for instance, that a certain amount of money per month can be spent on X per month without having to ask the other person. Or that calling in extra staff to cover a shift is okay without explicit permission from the other. Be clear with each other and "automate" some decision-making to be able to focus your energies on stuff that does have to be discussed and debated.

Once you've done a bit of chaos reduction with your current situation, start applying the *begin as you mean to carry on* principle to anything new. Ask yourself:

- Am I going to be doing this particular thing a lot?
- Is doing it this way going to end up being a habit when I get busy and distracted with all the other stuff?

- Is that habit going to screw me up later?

If the answer to any one of these is yes, then stop and figure out a simple way to handle it properly … from the beginning.

WHY ARE WE DOING THIS AGAIN?

 "Prepare for the worst; hope for the best."

– *Your grandma, probably.*

Running a business feels a lot like riding a roller coaster. It's awesome when you're on your way up a hill, terrifying when you're heading down to a valley, and you will frequently have the urge to barf. Some days, you might feel all three things before lunch. On other days, one of your children will do the barfing for you.

We'll discuss some specific coping tactics later on in the section on startup stress, but here, we're going to concentrate on an overarching strategy for dealing with the ups and downs. And that is: remembering why you started a business and/or a family in the first place.

There are probably dozens of reasons for going into business. Perhaps you saw a problem that needed solving. Maybe you found a way to make a difference in people's lives with your service. Or maybe you just straight up liked the idea of making some serious bank and started a business as a means to get rich. It really doesn't matter what

your reason is (as long as you're not screwing people or the planet over on the way, of course), as long as it has meaning for *you* and you can remember it later on.

Remembering your why is important for two reasons. First, it will help you through the bad times (and no matter how rock solid your plan might be, there will definitely be bad times). Keeping your reason for being in business in mind will help you through those rough patches. It will also provide a useful metric that may provide some much-needed motivation.

For example, if your reason for going into business was to provide peace of mind to seniors who need reliable grocery delivery, then spending a few minutes on a bad day calculating how many bags of groceries you've delivered to date will give you a great sense of accomplishment.

Second, strangely, remembering your why is at least as important, if not more, to remember when things are going well. This is because it helps you make sensible decisions. For instance, on those occasions when everything seems to be working properly and there is money coming in the door, you might be tempted to branch out into some new product line or splash out on a huge new location. Keeping the rationale for your business in mind will help you decide whether what you're considering is in line with your original purpose or just a distraction.

Just as in business, there are many reasons for having children, but here you must exercise a lot of caution when considering your why. In fact, focusing on why might actu-

ally be detrimental during tough times. Relationships are, by their very nature, emotional, and those involving children even more so. Your why for having children might be considerably different from that of your life partner's or society's expectations, or even the whys your children develop for *themselves* as they get older.

Ultimately, your why for having a family matters less than what you do for your children once you've brought them into the world. What *will* get you through your familial tough times is love and respect for your partner and children as human beings with their own foibles, wants, and needs.

Your Mission

...should you choose to accept it...

One of the standbys of any consulting engagement, and many a business seminar, is a SWOT analysis. In case you're not familiar with the acronym, it stands for Strengths, Weaknesses, Opportunities, and Threats. On a piece of paper divided into four, you're meant to list as many of each as possible, to help you identify what you're doing right, what you could be doing better, and what you have to worry about. Doing one of these analyses periodically is a good way to anticipate—and mitigate—potential problems.

Inevitably, though, you will get sideswiped by something you didn't see coming. Like what, you ask? Well, we have been through things like:

- A server meltdown
- A client not paying a bill to the tune of thousands of dollars (at a time when we could ill-afford it)
- A project manager suddenly leaving just two weeks before a huge project's deadline
- A major software purchase that went south because mission-critical features were not available as promised

The list goes on and on—and that's just on the business end.

Personally, we've gone through the same things as many of you have:

- Pregnancy complications
- Major illness in the family
- Flooded basements (on Christmas Eve, of course)
- Furnaces dying in the midst of a -25 °C cold snap[5]

And so on ... Life is life. Stuff happens.

What got us through these times was setting up—and later referring back to—a mission statement for the business and our personal mission statement.

We know what you're thinking. A mission statement? Seriously? It's true: these statements have a bad reputation. This is because they tend to be written by committee and thus end up being full of rather meaningless corporate

speak. Worse, some companies force employees to memorize and recite them as part of an overall program of team building. Ugh. *Double* ugh, in fact.

But done right, such statements can provide a way to keep you on track. For example, Scribendi's mission during our tenure was: "To help the world communicate more clearly, one comma at a time."

The key here is short and lofty. Short, because if you can't sum up your mission in the proverbial twenty-five words or fewer, you lack focus and need to rethink what you're doing. Lofty because humans need purposes bigger than themselves to stay motivated.

Our *personal* mission statement is simply to make everything we get involved with better than how we found it. This might sound a bit vague, but it's actually not when applied in our day-to-day lives. For example, Terry took on the presidency of a transportation action group with a view to radically improving the country's public transit network. This means he isn't satisfied with doing things to "raise awareness" of transportation issues; he has spearheaded the development of a study on how to actually fix the problems. This in turn will help him improve the economic prospects of our community.

In both cases, the work has a purpose, and it means we're not volunteering just for the sake of volunteering. There's nothing wrong with volunteering without an agenda of course, but if your goal is to make a difference, being strategic about it is important—especially when you're

trying to balance all the demands on your time. Otherwise, you end up attending meeting after meeting, being little more than a bottom end in a chair, rubber stamping things you don't care that much about.

Figuring It Out

If you're not sure where to start in building your mission statement or are figuring out the "why," then step back a bit. What do you value? Here are some soul-searching prompts (there are more in the workbook) on your values:

1. Is your neighbourhood just a place where you happen to live, or do you think of it as a community? Do you care either way? What, in your view, makes up a good community?
2. What social services do you think are important? Is health insurance something you value? What about support for veterans? Should low-income families have free access to sports and fitness facilities and libraries?
3. What do you love and value about your partner? Perhaps it's a sense of humour. Maybe it's his/her spontaneity. Or rock-solid stability?
4. What qualities do you admire in the people you consider role models?
5. What do you value in the companies and organizations you have to deal with? Face-to-face contact? Online chat capability? Streamlined forms? Good prices? What makes you choose to deal with one place over another?

DO IT BY THE BOOK

> *The whole principle came from the idea that if you broke down everything you could think of that goes into riding a bike, and then improve it by 1 percent, you will get a significant increase when you put them all together.*
>
> — *Dave Brailsford*

As we approach the end of this section on general startup principles, we come to one of the single best bits of advice we ever received about running a business: *build an operating manual.*

The idea here is to start writing down the steps for everything that you do on a regular basis, in such detail that anyone could come in off the street, pick up your "operating manual," and run your business.

There are two reasons for doing this. First, by writing everything down step-by-step, you force yourself to critically examine what you do on a daily basis. You'll be able to streamline what you do because you'll spot the unnecessary time-wasting steps or find entirely new processes that are much easier. Overall, your business will become leaner and more efficient, and be more competitive as a result.

Second, at some point—especially if you're serious about growing your business—you will actually *want* to be able to hand over a manual to someone off the street ... or at least

hire some employees and have them trained and working on your behalf sooner rather than later. With clear instruction manuals, you'll be able to start divesting yourself of each of the many hats you wear as a business owner, which will in turn free up your time to do what you do best: set strategy and goals.

Think about it: we're pretty sure you didn't go into business to be a bookkeeper (unless you *are* a bookkeeper, in which case, carry on) or the person who orders the stationery or the one who does the media buys. Those are all important jobs, to be sure, but you'll want to hand off to other people—people who, quite frankly, will probably be a lot better and more efficient at them than you!

Your highest and best use is being the big thinker.

Do you really need to write it all down? Can't you just verbally train people or show them how it's done as you bring them on board? Yes, you could, and obviously there should be one-on-one interaction when you hire employees and as you work with them. But ultimately, you want to empower your staff to be able to do their jobs *without* your help and without having to consult you at every turn.

If you keep most of the business knowledge inside your head, you will become your business's biggest bottleneck and obstacle to success.

With clear instruction manuals (and that mission statement we referred to earlier), your staff will be able to help you and make decisions that are in line with your goals.

But what if you never plan to hire staff? What if you're a solopreneur, like a life coach, or someone in professional services, like a dentist, and your business is based on the unique skillset you offer?

Write your manuals anyway!

Not only will you still benefit from the process of reviewing what you do, you will probably find that there are lots of things you *should* hire help for (e.g., booking appointments) or at the very least outsource (e.g., tax preparation) or automate using software. That will allow you to spend more time actually bringing in revenue, rather than just administering it. This is even more important when you realize that as a solopreneur, your product is actually your *time*. The more of it you can "sell" instead of spending on administrivia, the more you earn.

You may also wish to use the manual writing process to consider what might be unique about what you do or how you do it, with a view to scaling your operation later.

And here's some food for thought: While there are certainly a lot of benefits to being a solopreneur (managing staff brings its own headaches!), the single biggest issue with being one is that everything about your business depends on *one person*: you. That makes it very hard to take vacations, deal with emergencies, or even just nurse a simple head cold. After all, if you're not hustling, you're not earning. And all the advances of modern technology notwithstanding, there are, the last time we checked, only twenty-four hours in a day, so even if you are somehow

able to work flat out all the time, you will still be limited with how much you can make.

Unless ... you could discover what makes what you do and how you do it unique and find a way to package it and replicate it. Indeed, many solopreneurs have gone on to either create a franchise based on this thinking or found a way to teach what they do to others. For example, if you're a personal trainer who gets great results from your middle-aged male clients, you might think about creating a certification system for other trainers to be able to teach your methods to their clients.

Consistency Is Key

It was the third interview of the morning. Chandra looked down at the question sheet and nodded. It was time to pose her favourite query.

"Why do you think Tim Hortons® is so successful?"

For all of you non-Canadian readers, Tim Hortons® is an iconic coffee-and-doughnut chain, with hundreds of stores across the country, in big cities and teeny towns alike.

The answers to the question would vary:

"Because it was started by a hockey player."

"Because they talk about *fresh* as important to their brand: fresh coffee, fresh-baked doughnuts."

"Because they associated their brand with national identity."

Of course, there's no one *right* answer to this question. It was designed to see if the candidate could think critically about potential reasons for business success. But there was one answer that would earn the interviewee a few extra brownie (doughnut?) points:

"Because they provide consistent and reliable products no matter what store you walk into."

Bingo. As both Terry and Chandra had realized, a coffee bought in Halifax, Nova Scotia, was going to taste the same as a coffee bought in London, Ontario.

When we decided to get serious about writing down our processes, we went hard-core: we became ISO 9000:2008 certified. That means that we had to write down our processes in a prescribed way, establish key performance metrics, *and* submit to annual third-party audits.

We did this for a number of business reasons that may or may not apply to you. You don't need to have a formal process tracking credential, although it might be worth investigating what's available in your industry, especially if such a credential will give you a competitive advantage. And being accountable to a third party keeps you honest.

The key to any such system, formal or not, is using common sense when setting it up and using it. You don't want your processes to become so rigid that they never change; likewise, you don't want to be writing stuff down just for the sake of creating and filing paperwork. You need just three steps to get it right:

1. Get your important processes down on paper
2. Make sure other people can understand and follow them
3. Set a regular schedule for reviewing them to ensure that they're still both relevant and effective

This also has the advantage of making it really fast and easy to onboard new hires and to cross-train employees. Indeed, one of the things we heard over and over from our incoming staff was that it was the most organized and straightforward training they'd ever encountered. They also knew why their job was important and how they fit into the organization.

At home, there isn't a formal Johnson & Clarke Family Manual, but there is a bible: that shared digital calendar we mentioned before.

We happen to use Blackberrys® and Microsoft Outlook® (Hey! Stop laughing!); you could use an iPhone® and the native calendar feature, or some other combination. The tools here don't matter. The point is you want something that's digital, so you can share and, more importantly, *sync*. And you need to be absolutely religious about putting everything in it: work-related meetings, health-related appointments, the special events for the kids, your scheduled time off (more on that later) ... Absolutely everything.

If it isn't in the calendar, it doesn't exist!

Hot Tip

The real key to calendar and task management success is *recurring* appointments.

The *only* way we stay on top of the 101 things a modern family needs to do (give the dog her flea pill, take the car in for maintenance, change the furnace filter, pay the municipal tax bill ...) is to set repeating reminders for these things. Do this for everything you need to do on a regular basis (even if it's a yearly thing!), and you will save yourself a ton of "I need to remember to do X ..." related anxiety.[6]

Your Turn

The next time you start to do something that's a recurring task, open up a blank document file and jot down all the steps involved in completing the task as you do them. Save the document with a name like "operating manual." Make a backup copy of it on another device.

There, you're on your way to documenting your business! Wasn't that easy?

Bonus: Take two minutes to set up the recurring calendar appointment or recurring task in your to-do app for this process.

Rinse, repeat.

ONE THING AT A TIME

 "Patience you must have, my young padawan."

– *Yoda (maybe)*

Finally, one last principle before we do a deep dive into the various stages of family and business growth.

At this point, you might be thinking to yourself: Yes! Tomorrow, I will change *everything*. I'll get the business plan done! I'll reverse those six bad habits I've acquired! I'll get a key hook! I'll write out my billing process!

Hey, whoa there, speed racer! Dial it back.

As tempting and exciting as it sounds to make a lot of changes—especially changes that will help you bring your A-game to your business and family every day—it's important not to try to do them all at once. Our goal here is to reduce the amount of chaos and stress in your life, *not* add to it.

This applies especially to habit changes. If you change your toddler's bedtime routine at the same time as trying to squeeze time out of your evenings to draft a business plan, and you're also trying a new diet ... you're basically setting yourself up for failure on all three fronts.

Although we entrepreneurs are notoriously impatient (that's usually a good thing when it comes to being innovative and risk-taking), patience is a good thing to cultivate in

other areas of your life. As is a willingness to change things. *Make just one change.* And make sure the change is working for you, and *then* you can move on to the next issue. If it isn't working, you can roll it back and try something else until the problem is solved. It will make things much easier in both the short *and* the long run.

From here, we'll tackle some of the biggest issues you're facing in the Startup phase. But first:

What's the Impact Factor?

Reviewing your financials is kind of like police work. Long moments of boredom interspersed with moments of terror. ("We spent *how* much on that thing?")

But review them we must. And *revise* them we also must, if we want to the business to thrive. Finances are tricky things. There are usually only a few sources of revenue, but *so many* expense centres. Where do you begin to make changes? How do you avoid the analysis paralysis syndrome? Simple: use the "one thing at a time" principle.

In our case, we looked at the single biggest expense on our ledgers, which was bank and credit card fees. We pushed our vendor to give us better percentages and looked at ways to group transactions to avoid taking so many hits. It substantially improved our bottom line. We looked at the next biggest expense the following month, and so on down the ledger (until we reached a point where the effort expended in cutting costs was more expensive than just letting the costs go).

If you've been careful about expenses and/or you have a lot of fixed costs but can't really find anything that changes your bottom line substantially, focus on revenue. What's the *one thing* that would add the most profit? (Notice we didn't say revenue—more on this later.)

Prioritizing: Over to You

Have a look at all your pain points. What's causing you the biggest headache at work? What's messing you up Every. Single. Day?

And at home: How about your personal life and relationships? Make a list, and then prioritize the items. Pick the number-one item on that list and work to fix it. Only tackle the number-two item when you've made a successful change with respect to your first item.

LET'S TALK ABOUT GUILT

It's not about how much you do, but how much love you put into what you do that counts.

– Mother Teresa

Your baby is so cute. And growing so fast! You love your baby so, so much.

And yet ...

Three more emails just came in. You are VERY close to landing this client. Oh, and wouldn't it be cool if you could

offer that new feature you've been dreaming about? Just a few more minutes on the laptop ...

The Guilt. Oh good gosh, The Guilt.

Is there any force in the universe more powerful to a parent? Nothing crushes you so quickly or thoroughly.

The Guilt is *stealthy* too. It sneaks up on you when you're thinking about that time you gave the baby an extra cereal biscuit in order to finish a job. It attacks when you feel that sense of relief that it's finally nap time. The Guilt really, *really* sinks its fangs in if you miss a milestone.

Unfortunately, guilt is one of those things that can actually get worse with time, unless you actively work to prevent it in the first place.

So let's talk about how we can do that.

Doing Right by Your Children

In any of the impromptu discussions we've had with our fellow entrepreneurs over the years, the number-one family/business concern, hands down, has always been: Am I doing right by my children? No matter that the entrepreneurs we've talked to have been at all the various stages of their business, and their children varied in age from newborn to nearly out of the house.

So, in order to address this concern, we need to unpack it.

Foremost is the time factor: "Am I spending enough time with my children?"

Yep, entrepreneurial parents constantly worry about whether they're spending enough time with their children. Now here's the part where we'd like to reach out, pat you on the back, and make reassuring noises about how well you're really doing here.

First, the bad news. If you have to ask, the answer is almost certainly is: probably not.

Now, the good news.

Fortunately, although you likely don't believe it yet, time is one of the things you *can* control as an entrepreneur. Think about it: you don't have to show up at a specific place by a specific time every day to answer to a boss, because, well, you're the boss! While there will always be some type of external constraint on your time (e.g., if you run a physical store, you might need to be open at specific times to serve your customers), ultimately, you do have the freedom to choose *what* you attend to, in what order, and *when*.

This is one of those "mindset things." As an entrepreneur, your superpower is the power to decide.

That's so important, it bears repeating:

As an entrepreneur, *your superpower is the power to decide.*

So if you're concerned that you're not spending enough time with your children, the answer here is simply: spend more time with your children.

This might mean that you come home from your office (or if you're at home, coming out of your office) to eat all your meals with them, rather than grabbing a fast bite at your desk. It could mean, if they're very young, working only when they nap or go to bed for the night (we've done this). To get back to our store example, you might choose to close up early on Monday nights. Or spend the money to hire a trusted keyholder to get the store open and running for you.

Hey, we didn't say the choices would be easy!

The important thing to remember here is that everything *is* a choice. Everything.

The other important thing about spending time with your children is that, if you don't start doing it now, when your kids are younger, and your business is just getting off the ground, you won't do it later either. And the clichés about children are heartbreakingly true: they do grow up fast.

There are many aspects of life where you can play catch-up later; your children are simply not one of them.

The Entrepreneur as a Role Model?

What else do we mean by doing right by our children? Entrepreneurs also really worry about whether they're setting the best example for their children by being in business.

This is kind of an odd worry to have. We're pretty sure that doctors, for example, don't go around worrying about

whether their chosen profession sets a good example. However, part of this concern stems from the risk involved in being in business. For many entrepreneurs, there is a nagging, underlying feeling of recklessness that comes from starting a business. Many of us wonder whether this is what they want their child to imitate later. Or rather see them do something "safer."

Another aspect is the lingering disdain that society has for the so-called "merchant class." Consider some of the phrases we casually use all the time, like "filthy rich" or "poor, but honest."

Ugh.

The reputation of the business man or woman is not helped by news stories of unsavoury deals or business practices that surface with depressing regularity. Especially when we hear about utterly heartless corporate decisions or tone-deaf ad campaigns. Again, many of us wonder: Is this what I want my child to do? Or to think of me?

Take heart. We think you're setting a great example. Not because we're biased about your chosen profession, but because by being an entrepreneur, you're being true to yourself. Ultimately, that is what you'll want for your children: that they be true to themselves, whether that involves going into business or doing something completely different.

As for the reputation of unabashed capitalists like ourselves, well, as long as you run your business in a

morally, ethically, and environmentally sound way, your children will think you're a great example.

Plus, you'll be improving society's opinion of entrepreneurs in general, so thanks for that.

But What About Our Future?

Another huge source of family and business guilt comes from this question: What right do *I* have to risk my family's future?

The answer to this one is surprisingly easy: you have the same right as anyone else.

The employee who works for a big corporation risks his family's future every day because he could be downsized without warning at any time. The policewoman risks her family's future every time she heads out on the job and puts her life on the line.

You see, in this case, we entrepreneurs are not special. Everyone's occupation involves some degree of risk, and the potential fallout if something goes wrong depends not on your choice of occupation but how you manage the risk and prepare for a potentially bad outcome.

The aspiring entrepreneur whose business fails completely but who has only spent her savings might be better off than the corporate worker who gets the pink slip at age fifty-seven when he hasn't set aside anything for retirement or emergencies.

So, angst about your career choice? You can relax and let it go, grasshopper. Which is good because after the break, we'll move from The Guilt to The Doubt.

The Gut Check

Nearly every day, Chandra does a gut check, which involves asking: Did I do right by ... X?

Sometimes the X refers to her children. On other days, it might refer to someone within her business or maybe the business as a whole.

What does "do right by" mean? That will vary depending on you, the person or business in question, and the circumstance. For Chandra and Terry, it meant things like cuddling a toddler. Pushing the business in a particular direction. Making sure the dogs got walked. Checking in with Mum overseas to see how she's getting on.

Notice that it is X, singular—you're not going to be able to "do right" by everyone and everything every single day. That's both impossible and ineffective. But by doing this sort of regular check-in, you make sure that you don't forget important people and aspects of your life while laser focused on some particular goal.

Who's on Your List?

Make a list of everything and everyone on your personal "do right by" list. This should include business and life partners, kids, other important relatives, friends, employees, important projects at work, and important projects

around the house. You can consider listing them, with the most important near the top. Put this list somewhere special and refer to it as often as you need to.

Does it feel weird to "quantify" your relationships? You bet it does. No one is suggesting any sort of cold calculus here —and for heaven's sake, don't be a robot about this. This is not about putting ticks in boxes and patting yourself on the back. And don't feel you need to be Mr. or Ms. Money Bags about this either. Doing right doesn't mean buying something for someone. It can be a hug, a thank you, or time spent together.

Writing things down like this forces you to acknowledge what is important to you, and reviewing it regularly ensures that you do not forget important things in the hurly-burly of your life. That, more than anything, will help you deal with The Guilt.

DEALING WITH SELF-DOUBT

 Whether you believe you can do a thing or not, you are right.

— *Henry Ford*[7]

We love our children, we truly do. They're cute, they're ours, and we'd do anything for them. The same goes for our life partner.

But …

Every once in a while, especially on days when the colic just won't quit, or the toddler (or spouse!) has thrown her umpteenth tantrum over the crackers and cheese, there's this teeny little voice that quietly wonders: Does having a family, you know ... hold me back?

And then The Guilt drops on you like a ton of bricks for even contemplating the idea (see the previous section).

It's a perfectly natural concern to have. Healthy relationships take up enormous amounts of time. Children require heaps of attention and energy.[8] It's very tempting to think that you'd be making more progress on the business if you didn't have to spend at least half an hour just getting everyone loaded into the van Every. Single. Time.

Tempting but ... wrong. The thing is, you only truly appreciate the value of time after you've gone through a period where you genuinely don't have a lot of it to spare. Think back to your swinging single or child-free days. Were you a paragon of productivity? Did you crank through your to-do list with ruthless efficiency?

Or did you maaaaybe spend a lot more time with Netflix or the Xbox than you're willing to admit? Yeah, we thought so.

Chances are, you'll look back on that time now and think, "What the #$%^&! did I *do* with all my spare time?" You almost certainly dedicated a lot more time to fun activities like dining out, taking in movies at the theatre, messing about on the internet, and so on. Even if you were an

exceptional case and actually spent a lot of time working, you probably spent way more time futzing about with non-priority tasks than you needed to.

Work expands to fill the time available (if you let it).

When you have kids, especially little kids, your schedule tends to revolve around their needs, so you need to cram everything else into what little time is left.[9] So when you're finally able to put junior down and tiptoe away, the first thought that runs through your mind (after phew!) is: Okay, I've got half an hour tops. What MUST be done right now?

Raising a family forces you to prioritize.

Being a parent also makes you more creative and resource-ful. As your tots grow, you'll encounter all sorts of situa-tions for which you never received any training and where you just have to figure it out on the spot. (Chandra remem-bers being stuck in the back of a car with our firstborn and getting caught in a traffic jam that lasted nearly two hours; the car was overly warm, and there were no toys available. Good times.)

Finally, kids also ground you in a way that very little else can. For many entrepreneurs, their children are their reason for being in business in the first place. For others, their children remind them to get their heads out of their business and to remember to actually enjoy all the other good things life has to offer.

And there's nothing like having a child explain what you do to someone else to take you down a peg or two when you most need it. ("Oh, and what does Daddy do?" "Daddy swears at the computer all day.")

Then there's The Guilt's sibling, Self-Doubt.

We entrepreneurs quickly learn to talk a good game ("Delivered by Friday? Of *course* we can deliver by Friday!"), but inside we're just as full of insecurities and worries as the next person (Oh crap. Now what am I going to do?)

Self-Doubt will always dog you, but it probably peaks during Startup. This is because:

1. There's so much on the line at the beginning and
2. You haven't been in business long enough to feel confident in your decisions or in your ability to juggle it all.

Coping Strategies

There are a few approaches you can take to reducing Self-Doubt.

The first approach is to jot down a list of decisions you've made recently, big and small, where you can definitely say, "Yes, that has worked out well." This is a tremendous confidence booster when you need it the most.

The second approach is to give yourself a bit of perspective about your pending decisions. Ask yourself: If I make the wrong decision here, what's the worst that can happen?

Although it might *feel* like the answer to this question for every one of your decisions is "Argh! My business might die and I'll be a laughingstock!" You know that's not really true.

For example, if you're trying to decide between software platform A and software platform B, the consequences of choosing incorrectly might be that you're not as productive as you could be for the money spent. While that might not be an optimal outcome, it's also not the end of the world, *and* you will have the option of changing platforms later if it proves to be super annoying.

Remember, there are actually very few decisions in life that are completely irreversible.

A third approach—and this one is very powerful both in business and your personal life—is to ask yourself this gut check question: What was I stressing about a year ago today?

Nine times out of ten, you won't be able to remember. Which means ... while it seemed like a big deal at the time, it wasn't really, was it?

And guess what? The same almost always applies to your current worries.

Finally, another way to reduce the visits of Self-Doubt dropping by to rain on your ability to juggle it all is to ... stop trying to juggle it all! #Prioritize.

One of Our Mistakes

You wouldn't think choosing accounting software would lead to gnashing of teeth and rending of garments. But, well, it did.

Weeks of searching. Endless calls involving tedious sales presentations and demos.[10] Tedious negotiations. Finally, a contract signed. Software laboriously integrated with the website.

And then ... the software didn't work as advertised.

Mission critical for us, you see, was being able to handle multiple currencies. Our customer base was worldwide, so we needed to have our accounting software interface with our website to pull in orders and then efficiently deal with all the various customer combinations. A Japanese-speaking customer might start using our services in Japan, but then move to the US for graduate school, and then to England for work.

We'd made this clear throughout the whole process. Made it our number-one issue with anyone we talked with. Had been assured by the sales team we dealt with that multi-currency was no problem at all.

Except, of course, it was a major problem.

All that work and time and money down the drain. Plus more time spent trying to get out of the contract, and then we still had the problem of not having an accounting package that did what we needed it to.

But really? The doubt this led to was the worst part.

Where had we gone so wrong? How had this gone off the rails so badly? We'd been in business for several years by this point, so it was a real blow to our self-confidence. Didn't feel great to foul up in front of staff or in front of each other either. It hurt. A lot.

We learned what we could from it: we refined our procurement checklists and demanded better demos of the products we were close to settling on. We were also reminded of the importance of solidarity in front of the staff and of supporting each other, even when things went sideways. Sure, we could have pointed fingers at each other and had arguments at the office, but what would that have done to morale? Tanked it.

The Post-mortem

In addition to making a list of where things went right, as we suggested above, pick one (1!) thing where you went wrong and analyze it.

Pro tip: do this early in the day, not at night. *Everything* seems worse at night.

Now is the time to channel your inner Mr. Spock and be coolly objective. Where did it go wrong? Is there something you can do to prevent that thing from happening in the future? Was it out of your hands? What can you learn from the experience?

Other questions to ask:

- How much did it really hurt you or your business?
- Can you fix that part of it, or is this something you'll have to live with?
- Can you mitigate the damage?

When we did the post-mortem on our software acquisition problem, it turned out that there wasn't much we could have done differently. We went back over emails sent to various vendors, and we'd made the requirements very clear. The sales team we happened to deal with just—how shall we put this—made promises they couldn't keep.

Fortunately, because we'd been very explicit about what we wanted, getting out of the contract was easy-ish,[11] in the sense that we didn't have to get lawyers involved. We ended up buying an off-the-shelf package and writing our own integration software to get it to talk to our website. That taught us to look for simpler solutions in the future.

WHERE DOES THE TIME GO?!

> *Imagine life as a game in which you are juggling some five balls in the air. You name them—work, family, health, friends and spirit ... and you're keeping all of these in the air. You will soon understand that work is a rubber ball. If you drop it, it will bounce back. But the other four balls—family, health, friends, and spirit— are made of glass. If you drop one of these, they will be irrevocably scuffed, marked, nicked, damaged, or even shattered.*
>
> — *Brian Dyson*

Running a business with a baby in the house is *hard*.

Running a business with two (or more) children in the house under five is *even harder*.[12]

There's never enough time: the house to-do list gets longer, and the business to-do list gets no shorter, and you're pretty sure you've just lost the baby in the dirty laundry heap. You wish there was such a thing as a caffeine intravenous drip.

Sadly, there isn't one (at least not one that would be safe), so we must look elsewhere for coping techniques.

Go Zen

The first and best method for reducing your time-related stress at this stage is to ... let it go.[13]

You need to accept that on some days, fewer things will get done. The house will sometimes look like a toy store exploded in it—but that's okay. You were only able to write a small chunk of code for your app today—and that's okay too.

But, you rail, everyone else I know has spotless houses, kids in perfectly accessorized designer clothes, and knocks eight things off their business task list before breakfast! Facebook said so!

No, they don't, and certainly not in the Startup stage. They've just allowed you to see into their lives at certain, carefully curated moments, and that makes it seem like they have it all together all the time.

At our house, even now, we're pretty certain we haven't had all the dishes done and put away for more than five seconds since 2005. And in spite of our best efforts, the kids' trousers always seem to be two inches too short or have holes in the knees, or both. Don't get us started on their socks.

You also need to accept that some days, *nothing* will get done.

Nothing will get done. It almost hurts to say it!

We call these "body and soul days." These are the days when you are just too darned sick or too darned tired to do anything but keep body and soul together.[14]

Acceptance is really, *really* important. Once you relax a bit about this sort of thing, you stop beating yourself up about how much you've not accomplished. This in turn leads to less stress, less self-doubt, and, ironically, fewer body and soul days because you're not burning yourself out. This is especially true if you're ill; pushing yourself on sick days is only likely to prolong your illness.

Block Time

We know a lot of entrepreneurs who claim that they have attention deficit disorder and who wear the label proudly[15]. They tend to be the types who attend a conference, text while watching a presentation, and have a spreadsheet open on the laptop.

The ability to keep *track* of multiple things is definitely a good one to have as an entrepreneur. But in terms of what you actively attend to and work on, multitasking is absolutely not the way to go. It might feel like you're burning through a lot of tasks, but in reality you're wasting tons of energy shifting from one thing to another and probably not providing your best work on the stuff you're handling.

How many times have you crawled into bed, exhausted, feeling like you spent all day doing ... things, but didn't feel like you'd actually accomplished anything? That's the problem with multitasking.

We like the concept of "block time." When Terry needed to review and push code, he closed his door and reviewed code. Nothing else. When Chandra needs to write a blog post, she sets aside a block of time and does nothing but work on the blog post. This has the advantage of providing higher quality work and making you feel like you did meaningful work at day's end. And there are few things more important to an entrepreneur's soul than a feeling of accomplishment.

If you've been flitting from one thing to another for a long time now, you might find it hard to maintain focus for longer periods of time. Fortunately, it's a skill you can easily regain or perhaps even learn for the first time.

There are all kinds of apps and techniques out there for removing or blocking distractions, and we've listed a number of them in the resources section of the companion workbook, but we like to keep things simple (remember what we said about habit changes and simplicity?). Our method requires:

1. Shutting off or closing everything else
2. A timer

Seriously, that's it.

If you're going to work on, say, answering emails, open email up on your laptop, turn *off* your phone, and make sure the only thing you have open on your laptop is your email application. Set your timer for a short period (five

minutes if you're new to sustained focus, up to twenty for old hands), and do nothing but emails for that period. No phone. No text messages.[16] No social media. Nothing but the emails. When the timer goes off, if you're done, take a quick break and move on to another timed task, or go back to email after your break to get them finished. As you get better at focus, increase the length of time you stay focused.

A quick word here about ambient noise in your work environment. Many people claim they work best in a noisy café; others make use of white noise generators or put a movie or music playlist on an infinite loop. Others, like us, prefer quiet in which to work. If you find you're hitting a productivity or focus wall, try the opposite of what you usually do: if you think a café is best, try a quiet space for a while, or vice versa.

Routines and Schedules

Routines get a bad rap. People often complain about being "stuck in a rut" or "going through the motions" or talk about "the same old, same old." Entrepreneurs like to think of themselves as free birds and sometimes prefer to make things up as they go along.

There's a lot to be said for schedules and routines, however. They provide stability and reduce the number of decisions you have to make in a day, as we mentioned before. They allow you to make use of block time. If you have several projects on the go, they can help you move

them all forward over the course of a week, rather than accidentally forgetting about one for weeks at a time because of distractions. Whoops! Having block time will help you focus on meaningful decisions, rather than being derailed by frivolous ones you end up making when you're on the fly.

Your children will *definitely* appreciate routines, as it makes them feel more secure. Remember, for children, most things are still new and they are constantly learning. If absolutely everything is in constant flux, then they'll get cranky and irritable and act out. Overstimulated! If they have at least some sense of constancy in their lives, they'll be happier for it ... And so will you!

Here are some important tips for making routines and schedules work properly in both your business and your home.

1. Consciously create a schedule or routine. Stick to it as much as possible. Too often, we let incoming emails or demands from staff or clients dictate how our days go. Remember your superpower: decision-making.

2. On the flip side, don't set a schedule so tight that the slightest hiccup sends it all spiralling out of control. Traffic jams happen. Kids have meltdowns. Your appointment might cancel. Create a schedule that allows you to roll with it. Do you remember the freedom of getting a

"spare" in high school or college—a period with
no scheduled class? Give yourself some of these.

3. Likewise, teach your kids the same skill. Don't set
up routines that are so rigid that they can't cope
when things go sideways. For example, one of our
toddlers liked one blanket and two bears in the
bed with her and has two favourite songs she likes
to hear before bed. But before the routine became
too set in stone, we varied the blanket, sang the
songs in a different order, and even played with
the words from time to time. And the bedtime
bears[17] stay in the bed all day, so there isn't a mad
scramble every night to find them.

Keeping Track

As some of you might remember from the pandemic lock-
down period in 2020, homeschooling can try a man or
woman's soul. It's much harder to teach your own kids than
someone else's because it's nearly impossible to remain
objective about their progress. And because they have a
keen insight on how to press your buttons. All of them.

We'd homeschooled for years before the pandemic shut
down schools, so we pulled out all the tools again. Chief
among them was The Clipboard™.

Okay, not really trademarked, but it maybe should have
been. On the clipboard was a single sheet of paper and a
four-by-seven grid. Four for the number of kids, seven for
the days of the week. In each square were the day's assign-

ments for each kid. Chores and extracurricular activities were included, as well, so we didn't forget them. As the kids went about their week, we'd use a marker or highlighter to cross off what got done. We used a clipboard because it was easy to spot amongst the piles of books or dishes, dog toys, etc.

Does this sound ... anal-retentive, as the saying goes? Probably! But rest assured, we didn't wield it like some annoying football coach complete with cap and whistle. And the kids were free to do what they liked after the list got done.

Did it make the week go a lot more smoothly? Yes! The children knew what was expected of them, we didn't go nuts trying to figure out which kid was supposed to be doing what bit of schoolwork, and it was super simple. Chandra kept a copy of the list on her laptop and tweaked it every few months as the kids got older and various things changed. And on days when kids were sick or there was a holiday or we just felt like doing a day trip, we tossed it.

Pick Your Own Method

If a clipboard isn't your style, maybe consider a whiteboard in the kitchen with just that day's list. If you're into gadgets, a shared digital calendar on a wall-mounted screen will do. Heck, a simple spiral-bound notebook works. Whatever suits your style and is something you'll stick to using.

The key is not the type of tool or even how firmly you stick to the day's plan. *The key is thinking out how you want the day to proceed rather than just letting things happen to you.* Absolutely go with the flow when you need to, but for that all-important sense of accomplishment and forward motion, nothing beats being able to cross stuff off a list.

It's also the case that knowing all the moving parts of your day, and all the dependencies, means you *can* adjust things on the go with confidence, knowing you won't inadvertently screw something important up.

THE TWO MOST POWERFUL SCHEDULE HACKS FOR ENTREPRENEURIAL PARENTS

 "Destiny is not a matter of chance; it is a matter of choice. It is not a thing to be waited for, it is a thing to be achieved."

— *William Jennings Bryan*

While the above tips are great, there are two hacks that really moved the needle for us in terms of reducing The Stress, The Guilt, and Self-Doubt, all while improving productivity.

It's kind of like the Separation of Church and State ...

The first hack is to *set up your schedule so that there is work time and there is family time.* And keep them separate as much as possible.

If this sounds obvious, it is. Buuuuttt, we bet you're not doing it.

Because if this also sounds tough, it totally is.

Both running a business and raising kids are all-consuming activities. This is especially true for startups being run out of your home, because your children have constant access to you. And thanks to your smartphone, your business does too.

If you let it.

Think back to all the times you felt most frazzled, or all the times you lost it and yelled at your kids or your spouse. We'd bet money that those were the times you were trying to work with kids nearby.

("Dad? I wanna cookie? Dad? Dad? Cookie? Dad? Cookie cookie cookie? Dad? DAD! DAD! DAD! DAAAAAD!")

Cue the *kaboom!* from you. Cue the child tears. Cue The Guilt. There goes your ability to focus for the rest of the day too.

Obviously, when you have a newborn, you don't have a lot of options until they start sleeping through the night and have consistent nap times.[18] As they get older, it becomes progressively easier. You can work during nap times and when they're asleep for the night. You can schedule grandparent time if you're lucky enough to have a supportive family. You can even set a specific video time every day as there's no harm in putting on *Sesame Street*® or something

like it as an activity. As long as when that ends, you switch back into parent mode and give them your full attention, and you don't rely on videos and electronic to keep them occupied all day long. They need *you* too.

It's also critical, if you are currently working out of your home, to set up a business area of your house that is off-limits to everyone not in the business. Don't try to work in the playroom, and don't let your kids come crashing into your den anytime they feel like it. Ground rules like this make it easier for everyone to know how to get along. (Begin as you mean to carry on!)

If you don't have a spare room, get creative: sacrifice a closet, convert half the laundry room, *anything* to get yourself a clearly defined space with a *door*. If you have absolutely no space to spare, find out if there's a co-working space available in your area. This is a kind of time-share or desk-rental arrangement, where you pay a set monthly fee for access to professional office space, and it's typically cheaper than setting up an office on your own. Good facilities will include access to a kitchen, a boardroom, and sometimes even reception and mail services. Definitely pay extra for an enclosed space if you can afford it because being distracted by adults wandering through is only marginally better than being distracted by your kids.

The second hack, and the one that took us the longest to figure out, is to be completely *unconventional in your scheduling*.

We both worked in our business: Terry looked after finance and IT, and Chandra oversaw daily operations and marketing.

Both of us trying to work and both of us trying to look after kids at once was a complete failure. It was never clear whose turn it was to change the diapers or do the cooking, and the kids didn't know which person was "in charge" at any given moment (although they used this confusion to their advantage a few times to score cookies until we wised up!).

We couldn't afford childcare. We had to get creative.

First, we tried alternating days: Terry would work all day Monday while Chandra would take a parenting shift; Chandra would work all day Tuesday, while Terry wore his Dad hat. This worked, but only to a point. Longer gaps between work shifts made it hard to pick up and get back into projects, and all day with the kids was ... well, allllll day with the kids.

Finally, we hit upon the tag team concept: Terry goes to work early in the morning, and around lunch, we swap, with Chandra going to work in the afternoon and into the evening. To this day, our children call these "half-and-half days." This worked better for the children, too, because a less wrung-out parent is a more patient parent.

We won't lie: this wasn't always the easiest schedule, because it effectively meant we were cramming two eight-

hour shifts each into a single day, and often on weekends as well. We're also pretty sure our staff thought we were nuts.

However, as we became more efficient and the kids got older, we pared this down to four-hour shifts, with—*gasp*—most evenings and weekends off. We also have remained flexible; sometimes we swap mornings for afternoons, and sometimes we do full days in to allow for greater amounts of block time.

You may or may not have the same options we do; you might have a different business than your spouse, or one of you might have a job rather than being in business. The point is, we threw out the conventional way of doing things and crafted a schedule that worked for us. There's no law that says you have to work 9 to 5, or from Monday to Friday.

Other Things to Consider

One other unconventional thing we did—at least by today's standards—is have only one car between us for many years.

We bring it up here because car use is one of those things that society (and marketing) kind of pushes us into. So, just like your schedule, it's something you should second guess.

It's definitely not the healthiest thing we can do, from a body fitness point of view or a pollution perspective. Not to mention what it does to our bottom line! Between gasoline (or petrol, depending on where you're from), maintenance, repairs, and insurance, they're a huge drain on your finances.

So, we did without a second vehicle for probably the first twelve years of our marriage. That was also a schedule hack in its own way: we had to think carefully before committing to things because it meant rejigging the schedule to accommodate a drop-off. As a result, we wasted less time on frivolous trips to the store to pick up one or two items, and we walked more—and that doubled as our fitness time.

Obviously, we could do this because we both worked in the same business; that might not be the case for you. But ... consider whether you could change things up so one of you drops the other off at work? Or reconsider what you drive: Is there something smaller and cheaper to run that would also reduce the number of trips to the gas station? How often do you run your minivan or SUV full of passengers? Could either of you bike or scooter? Better yet, can you go hybrid or electric? (We went hybrid in 2008, electric in 2017. It's such a smooth, quiet ride, with so few maintenance costs, we'll never go back to gas.) Do you really need to *own* a vehicle, or would it be cheaper to use public transit, on-demand transit, ride share, or the occasional rental?

Put Your Thinking Cap On

How might *you* rethink your life? How many things are you doing just because that's the way it's always been? Hunt down the biggest time sucks or budget drains in your life.

PROTECTING YOUR HEALTH

 The greatest wealth is health.

— Unknown

There are probably what, three million books on what to eat and how to exercise? Which one of these is the correct way?

We have no idea. Sorry.

Here's what we do know: as a startup entrepreneur with children, you probably feel like crap most of the time right now. You're sleep-deprived, and you haven't seen the inside of a gym since high school. You're likely not eating well.

If you're a woman, the expectation is that you should be able to immediately bounce back from pregnancy within weeks (or is it mere days?) like the celebrities supposedly do. If you're a man, you're meant to be sucking back protein shakes and working on your deadlifts like all the other bros. And both men and women are supposed to be following diets that seem to involve a lot of careful measuring and planning and preparation time you just don't have.

Worse, you all feel guilty about what you're not doing "right."

Repeat after us: *it's okay.*

In our humble opinion, there are two major problems with nearly all the diet and exercise programs out there, no matter what their underlying principles or nutrient profiles. The first is that no one diet fits all, so something that works for all of your friends might not work for you.

The second is that they're almost all designed by people who do "health and fitness" *for a living*. That is, they're personal trainers or nutrition gurus or whatever. The regimens they prescribe don't seem particularly onerous to them because these coaches don't have to work in special diets and workouts in addition to their day job because special diets and workouts is what they already do for their day job!

So what's an entrepreneurial parent, especially one working extra-long hours at the Startup stage, supposed to do?

Everything that you can *reasonably* do, of course. Compromise is the name of the game right now.

To Sleep, Perchance to Dream

At this stage, especially if you have very small children, you're unlikely to be getting eight hours of rest a day. Indeed, none of our children slept through the night until they were about a year old.[19]

We coped with this the same way we coped with our work schedules: we took shifts. We aimed for consistent bedtimes and as much unbroken sleep as we could.

Chandra, being the night owl, would stay in the living room with the baby and get up with our tot during the wee hours of the night. Then Terry would get up early in the morning and we'd swap, allowing Chandra to get some unbroken sleep in the bedroom before the work day started.

By our second child, we also learned to stop counting the hours we *weren't* getting. The only thing worse than not getting enough sleep ... is not being able to get to sleep because you're too busy stressing about how much sleep you're not getting. (You know you've done this.)

One other very important thing about sleep and this stage of your life: as much as possible, avoid making major decisions when you are severely sleep-deprived.

We'll say it again: do not make major decisions while severely sleep-deprived, *even if you think you feel okay.*

Our worst mistakes were invariably decisions we made when we were sleep-deprived—yet, as the saying goes, they seemed like good ideas at the time. Put off those big decisions if you can until you're in a position to get better sleep (e.g., the baby is regularly sleeping through the night); if you can't, find some way to get at least two solid nights of sleep before thinking about and making your decision.

Exercising Your Options

Exercise fads come and go; as we write this, we seem to be in the Extreme Era. We could be wrong, but you're probably not feeling motivated to even try, much less regularly

do, anything involving the words supreme,[20] boot camp, shred, CrossFit®[21], etc. This is a good thing, actually: attempting such a thing, without building up to it, is only going to end in pain and injury, and demotivate you completely.

Other workouts are equally trendy (hello Pilates, Zumba®, drumming ...) but may not work for you, depending on your current fitness levels, access to equipment or a gym, and whatever injuries or chronic conditions you might have.

So what's the secret to fitness? What's the best workout routine for busy entrepreneurs?

The one you actually enjoy doing.

There's no point in forcing yourself through a tortuous class that you hate (and eventually end up avoiding) just because it's currently the "in thing" or the one getting all the media attention because of its vaguely science-y approach.[22] If a biking class bores you to tears and gives you saddle sores, why not sign up with a for-fun soccer league instead?

We enjoy a variety of activities and mix them up as much as possible. Our personal favourites include swimming, hiking, weights, yoga, and lately, walking the dogs. Because we actually like doing these things, we're more likely to do them more often.

We also make a point of deliberately writing them into our schedule, otherwise they don't happen. Someday is not a

day in the week.

Food for Thought

There are probably more diet plans to choose from than there are actual people on this planet.

Okay, maybe not, but some days it seems like it. And it's so hard not to feel guilty about every bite you take when the experts are telling you that you will die a horrible premature death unless you only ever eat organic kale dressed in nothing but extra virgin olive oil and pink Himalayan salt.

But let's face it, at this point in your business and family development, you are likely not eating as well as you could, mainly because of time pressure. When you're working flat out and getting very little sleep to boot, spending up to an hour every day preparing dinner is just not in the cards.

Sitting down and carefully planning out meals a week or month in advance? Probably not going to happen. Doing all of your cooking on Sunday and freezing it all? If you can manage it, we salute you. We sucked at that.[23] We still do! Stick to simple, quick-to-prepare meals on weekdays; save anything more complicated for the weekend. If you must use prepackaged stuff, make sure you're buying quality and with not a lot of salt and fillers.

The Best Health Hack: Your Kids!

It sounds strange to say, because we can often think of our children as obstacles to our health. They cause us a lot of stress, they definitely cause us to lose sleep, and if they go

to daycare or school, they seem to bring home every cold and flu bug in existence.

The funny thing about our children, though, is that we will do things for them or on their behalf that we wouldn't do for ourselves.

It's very easy, when you're sitting by yourself on the couch, to stay on the couch and skip a walk in the local park. When you have children, you tend to think about how the fresh air would do them good, and how some exercise at the playground would help burn off some of their energy and maybe even provide some socialization time depending on how many other kids are there. Likewise, you probably didn't think twice about getting by on nothing but mac and cheese for a whole week when you were a student, but you wouldn't feed your kids that way.

So if you're having a hard time avoiding desserts throughout the week, go ahead and use your kids as the "excuse": you can't have sugary goodies in the house because they're not good for growing children.

What Worked for Us

1. Plan your meals while doing grocery shopping. Terry is awesome at this. Instead of just buying what looks new or interesting (like Chandra does), he will check out the sales, base a meal around something, and purchase any accompanying ingredients. Then he writes the meal possibilities on the kitchen whiteboard.

2. Shortcut purchases. Sure, right off the farmer's truck and freshly prepared is the ultimate. But those precut and frozen vegetables, for example, are just as good nutritionally, and you are far more likely to eat your veggies more often if they're simpler to prepare and cook, right?

3. Super-shortcut purchases. There's bound to be at least one night a week where you're slammed for time or where you're just too tired or sick to cook. Why not plan for this? Set aside one of those frozen, boxed jobs that you just throw in the oven, warm up, and serve. Another good alternative is one of those deli rotisserie chickens and a salad. Throw in a loaf of nice bread and a bottle of wine to really splurge, and you're practically a gourmet.

4. Avoid temptation by not buying it! Will power is overrated.

5. Go ahead and cheat. Schedule one day a week where you can eat anything you want (assuming of course, you don't have a medical condition that strictly prohibits certain things). Why? Because it is infinitely easier to stay on the wagon *most* of the time if you know you don't have to stay on it *all* the time.

6. Don't sabotage each other. It is vital that you communicate your exercise and diet plan to your partner. You don't have to be on the same plan, but you should support your partner!

7. Don't do the absent-minded sandwich-at-the-desk

thing. You'll eat less if you consciously enjoy the process of eating a bit more.

8. Teach the kids how to cook! Not only is this an important skill that will save them money (especially at college), you will, when they're old enough to do it on their own safely, be able to ask them to cook now and then. Many hands make light work.

HOW TO PASS THE STRESS TEST

> *People become attached to their burdens sometimes more than the burdens are attached to them.*
>
> – *George Bernard Shaw*

There are many sources of stress, and people feel these stressors to varying degrees. Where one person might be completely freaked out by the idea of having to take a certification exam, another might not think twice about doing one ... and yet the thought of going to the dentist makes them break out in a cold sweat.

In general, though, stress comes from feeling a lack of control.

You can feel stressed by the children getting into a fight, especially if they do so just as you're trying to clear enough debris from the kitchen counter to cobble together some lunch. You can feel stressed by having to make a presentation because you're not sure whether it will be well received or about how you might be judged.

There are basically just two sources of this loss of control: *the stuff life does to you* ... and *the stuff you do to yourself*. Fortunately, you can do something about both of these.

First, Mitigate Life

It's true that life can throw you a lot of curveballs, but if you'll permit us to extend the metaphor, you can probably hit a lot more of these out of the park than you think.

Earlier, we talked about establishing a vision plan. That was a happy, optimistic, and forward-thinking exercise. Now we want you to put on your pessimist hat and make a list of all the potential obstacles between you and your goals.

For example, if your goal is to someday send your children to a big name college, then the most obvious potential obstacle is a lack of money for tuition. Another goal might be to sign your favourite celebrity as a spokesperson for your company; an obstacle here might be not making the right connections to get this done.

This is also the time to list your fears. These might include things like wondering whether you can trust a business partner to stay with you when the going gets tough or worrying about whether an ailment that runs in the family might affect you one day, too.

Don't forget to include big events. That includes natural disasters, economic downturns, climate change, etc. If we learned anything from the 2020 global pandemic, it ought to be that we should be listening to the scientists and researchers who try to alert us about potential problems.

This will be a bit frightening; try not to scare yourself witless here. But do take this opportunity to face up to your

fears. As difficult as it might be in the very short term, simply identifying and acknowledging your worries will make you feel much better. When you put a name to something, you have power over it.

Now go back over your list and think about what you might be able to do, however small, right now, to eliminate obstacles or prevent or alter potentially negative outcomes.

For example, you may be extremely worried about what might happen if there was a fire in the building where your office is because you currently don't have enough money for insurance and you couldn't afford to replace your laptop if you lost it.

Your first mitigation step could be to get access to a cheap offsite data backup service so you are at least protecting your mission-critical files, like your customer list. Your second step might be to prioritize getting business insurance over other expenses. (Beware the cost control trap: if you're competing based on cost, cutting important stuff like this is not sustainable in the long run, and it will bite you in the butt when something goes badly wrong. Find another way to compete!)

Do these baby steps completely eliminate the problem? No. But there is huge value in taking action. Why? Because you will have gained *some measure of control*.

Remember, stress comes from feeling a lack of control.

Obviously, there will be some things on your list of obstacles, fears, and worries that you can't do much about. A

hereditary disease might ultimately turn out to be unavoidable in the long term (although taking care of yourself can reduce your risk in some cases). But even here you can mitigate by consciously planning for a worst-case scenario as you grow your business—making sure you have critical illness insurance coverage, for example. Do you have a succession plan in place? Who takes over your role, or even your business, if you become ill or worse?

There is almost always something you can do for any situation. Even taking baby steps is preferable to expending lots of energy on numerous nameless worries, or worse, being blindsided by something you didn't—but should have—seen coming. The goal here is to make yourself—using the term popularized by Nassim Taleb—"antifragile."

Find the Secret Hidden Stressors

In previous sections, we covered the other, somewhat more obvious things we do to stress ourselves[24] out, by fixing your schedule and optimizing diet, exercise, and sleep as much as possible for your current situation. But what about the hundreds of little stressors in our lives that we don't even realize are dragging us down? How do we find those?

Ask yourself this question:

What *social conventions* or *unspoken rules* are you following that are actually causing you to waste time and lose energy?

Life is full of little rules and accepted ways of doing things. Like our habits, these conventions have some advantages: they can reduce the number of things you have to actively consider and decide. But they're almost never the most effective way of getting things done.

Conventions can also cause anxiety if we feel we're somehow not meeting society's expectations if we don't or can't follow them. For instance, we recently talked with a couple just starting their business and who also had just realized they were pregnant for the first time. They were freaking out because they had gone window shopping at some speciality baby stores and didn't know how they were going to afford a complete "nursery set" and the "diaper disposal system" and the "travel system" they had seen all of their friends buy.

They hadn't consciously realized that, while there are certain things you can't compromise on (e.g., a new, safety-tested baby car seat), there are a lot of things that are simply upsells or designed to help you "keep up with the Jones" (e.g., "diaper disposal system" = a garbage pail). They were stressed because they were following the currently accepted way of setting up for a baby; yet, there was really no need to. Grandma didn't have all this stuff, and your mother likely didn't either.

What about conferences? Conventional "wisdom" suggests that you need to attend lots of these to learn and to network. Think back to the last three you attended. Are you still in touch with anyone you met at them? Did you

action anything you learned? Unless you've been very, very selective and thoughtful about what you attended, probably not.

Or how about early mornings? *Everyone* says that to be successful, you must be an early riser. But what if you're just not a morning person?[25] Trying to follow that particular rule is just going to stress you out and make you miserable. And vice versa: trying to be a night owl if you're not one isn't going to work. And remember that whole morning/evening shift thing we talked about before? There can be advantages to partners keeping different hours in the day.

Everyone also complains about how much time email takes up, but in our experience, phone calls are the real problem. If you're looking to purchase something, a sales rep wants to schedule a call. If you've signed up for a service, an account rep wants an onboarding call. Other people want calls "to touch base."

And don't even get us started about the calls you have to make to get customer service from some organizations. On hold for an hour, transferred from department to department, explaining your situation over and over ...

Unless you have a real relationship with the other party, or what you're dealing with is particularly complex, *ninety-nine percent* of these calls are huge time wasters and achieve very little. They are also a source of lost time before and after the call. Before the call, you'll find you don't get into bigger things on your to-do list because you

know you'll have to interrupt yourself. After the call, it will take you as much as twenty minutes to get settled into the rest of your day, and that's assuming you don't have other calls scheduled.

Driving, too, is actually a huge time suck and something that can be unpredictably stressful, to boot. Lots of people don't think twice about driving themselves everywhere because we're acculturated to think that driving = independence. We prefer to take public transit for anything longer than say, half an hour. It's a three- to four-hour drive from where we live to Toronto; we always take the train. That's three or four hours of good work time, or even just unwind time vs. fighting traffic time. That's worth the ticket price! And a business class ticket for the train where we are includes a decent meal and drinks, which also saves time hunting for a restaurant at the destination, so for us that upgrade is actually a cost saving.

If you take a close look at your life, you'll probably realize that there are dozens of things stressing you out that stem from conventions. Remember your superpower: decision-making. You have the power to decide which ones serve your interests and which ones don't.

Speaking of stress, now we're going to move on to talking about money—or, if you're like most startups, a lack of money. But first ...

Here's What We Did

After we sold Scribendi, we took time off to wind down. Then, after a lot of debating and testing out ideas, we decided that our next business was going to be a board game café and independent book store. We live in a small town, and we wanted something that was going to be a community-building venture. We'd scouted locations for about six months, and finally, in December 2019, we initiated negotiations on a lease.

Yeah, 2019. Right before the pandemic hit.

We were fortunate in that we hadn't signed a rental agreement before everything went sideways and that we'd chosen a location that was going to have enough floor space to provide distancing when things eventually reopened. Still, it was pretty stressful. It didn't help that we'd put money into a few other projects that were also badly stalled and that the stock market was all over the map.

So, we prioritized the development of a document that had helped us back at Scribendi: an Emergency Preparedness Plan (EPP).

The EPP was basically a long list that could have been called "What to Do When Things Go Wrong and Who Should Do It." We listed all the things that could threaten the business from the mundane (web server dying, snowstorm) to the infrequent (flood, fire) to the rare (yes, that included epidemics). For the café and store, we also did

some brainstorming on how we'd keep the business solvent in the event of another lockdown.

What's on Your List?

Create your own EPP.

The typical response to large, unpredictable potential situations is to try to ignore the possibilities. But really, what you're doing is worrying about it, consciously or unconsciously. *Knowing what you'd do in an emergency can go a long way to reducing overall stress on a day-to-day basis.* Not to mention that having a contingency plan is just good business sense!

Remember that your first priority must be keeping your employees and customers safe. All else will flow from that.

MONEY WOES

 I've been rich and I've been poor. And, believe me, rich is better.

— Beatrice Kaufman[26]

Businesses fail because they run out of money.

Many marriages fail because of money issues.

It's safe to say that money is a major source of stress for startups and young families.

Business owners have it tougher than most people just starting their careers, too. There's no paid vacation; indeed, there's no option for vacation time at all. Often there isn't unemployment insurance, there isn't a pension plan, and there certainly isn't sick leave. When you're just starting out, you can't even get someone to take your shift or cover for you.

We can't speak to the specifics of your financial situation, but here are some guidelines that will help you get through this period with your sanity—and your wallet—intact.

The Green Monster

We are constantly bombarded with images of conspicuous consumption, especially in North America. We see ads for Italian leather couches, granite countertops, and humongous television sets, all for supposedly middle-class suburban homes. We're encouraged to buy large pickup trucks originally designed for contractors and farmers, with over-specified towing and hauling abilities that an urban driver will never, ever use. Our babies are supposed to have designer clothes, and "photo shoots," once the preserve of the rich and famous, have become a "must-have" for all of us average Joes.

It's hard not to feel jealous or envious; in fact, that's the point. Our society is geared to make you feel like you need more or better stuff. You just need to recognize when you're being upsold on a lifestyle, so that you can control when you buy into it and how much you do. Your focus

should be on what makes *you* happy and more productive, not what the ads tell you should want.

If a home décor magazine leaves you feeling deeply unsatisfied with your current home, stop buying it. If watching a reality TV show about fancy car makeover makes you want to go and kick the beater sitting in your driveway, stop watching it. Give the luxury lifestyle websites a miss for a while too, and anything else that makes you anxious about your finances. You will make much better financial decisions when you're not feeling pressured about your status.[27]

Stop Spending Before You Have to Stop Spending

The equation for staying solvent is pretty straightforward: earn more than you spend. Because you've been reading this book from cover to cover, you've already discovered the value of a business plan, and you're working on the earning part. Now you need to work on the spending part.

The key here, though, is less about *what* you cut and more about *when* you cut. If you trim the fat before you have to, you feel virtuous. Slashing expenses because you just don't have the money anymore feels like failure.

Take a good look at your home life expenditures. Many money gurus will have you start by cutting all of your little indulgences, like your daily latte. We disagree. While it's true that these things can quickly add up, we'd suggest you look at the big-ticket items first.

Here are some examples:

- Can you renegotiate your mortgage? Do you have to live where you are right now, or would another neighbourhood, another city, or even another region be better?
- If you have a car (or two), is there another vehicle that would be substantially cheaper to run?[28] Could you get by with one car? Heck, do you even need a car, or are there viable public transportation options locally?
- When you're renovating at home or your office, how much do you need to tear down completely, and how much can you simply refurbish? We saved tens of thousands on a kitchen renovation by refacing our cupboards rather than ripping out and buying new. (We also saved ourselves future expenditures by going with a classic look, so it won't seem "dated" ten years down the line.)

These types of questions might involve some short-term pain, both in terms of your time to rearrange them and any penalties or expenses involved. But they could save you tens of thousands of dollars over time. And money you don't have to spend can be saved, invested, or put against any debts you might have.

Then you can move on to other expenses that aren't as big but do mount up.

- How many streaming services are you signed up for? Do you use them all, or could you drop one or two?
- What about phone contract features? Does your usage match what you pay for?
- What would happen if you called up and asked for a loyalty break or suggested to the sales rep you've been looking at competitors and needed a reason to stay?

Once you've been through this exercise, you should have trimmed a lot of fat and yet still be able to enjoy that daily latte or whatever your preferred indulgence[29] happens to be.

In your business, the biggest temptation you'll face is buying more than what you really need, especially if you're talking to salespeople about your purchase.

It can be exciting splashing out for your office or purchasing top-of-the-line equipment for your manufacturing facility. There is definitely some value in not looking like a fly-by-night organization, especially if you're running a business that involves having clients at your location. But there is no point in looking absolutely fabulous for six months but then having to close up shop because you took on too much debt to look that way.

What you really need to do is figure out what you can make do with right now that will:

- Help you grow
- *Or* at least not hinder your growth
- *And* not be too expensive to replace or upgrade in the future as your needs change.

Lucky for you, you've decided to start a business when the cost of so many things has dropped to a mere fraction of what it once was.

Back in the day, when we first started Scribendi.com, long-distance phone charges were still a big deal, and getting even a small run of business cards done up was two to four hundred dollars, with letterheads and envelopes adding a few hundred more dollars to the bill. Software to do the most basic of things could run into thousands of dollars! Now, you can get stationery done up at much lower cost; there are dozens of options in each software category, and the cost to use them is generally only a few dollars a month; there are plenty of options for finding discounted new, refurbished, or used equipment; and you can even outsource manufacturing and staffing.

Here again, start by looking at your biggest expenses first. If you have an office or, you'll want to determine if the visibility you think you're getting in the location you've chosen outpaces the rent or lease payments you're making. Try asking your customers how they found you and what part of your region they're from. You might discover that a plaza location in the suburbs would be better than the high-priced downtown location you currently have. If your business doesn't require foot traffic or visibility at all, there's no

point in paying a premium for visibility; an office closer to home might be just the thing (and less stressful to commute to as well).

Our generation, many years distant from the privation of the Great Depression and two world wars, has largely forgotten concepts like "secondhand," "hand-me-downs," and starting small. These are the concepts you need to get you through the Startup phase. *Only buy what you need.*

Spend It Better

You will notice in the previous section about spending that we did not use the word "cheap." Unless you absolutely have to have something right now in order for your business to function, wait a while and save up for the quality version of what you need.

This is especially true at home. Go for solid construction and classic design over trendy, designer label or licensed products, especially in your closet. As a bonus, you'll avoid the dissatisfaction you'd experience when the design trend shifts and you suddenly feel everything in your wardrobe looks outdated!

Other People's Money

It's true: you need to spend money to make money. The question is, where do you get the money in the first place?

Loans come to mind, but unless you can get a really low interest rate, they can be expensive. You also need a solid relationship with a calm banker; otherwise, when the going

gets tough, there's a strong risk the bank will get nervous and call in its loan. This, as Terry likes to say using his classic British understatement, is not helpful.

Loans from friends and family are a possibility, but here the risk is in seeing a relationship go sour over money. What if your relative gets nervous and wants his money back? What if a friend hits hard times and *needs* her money back? Ugh.

Other forms of financing might involve giving up equity, which could be very costly in the future, or having to take on an advisory board. The right people on an advisory board can really propel your business; the wrong people can burn through a lot of emotional energy and get in the way.

So what else is there?

1. Keep your day job: The absolute best way not to get too stressed about your finances is to keep your day job[30] for as long as possible.
2. Grants: Many grants go unused because few people know about them. It's worth the time to research what might be available to you based on your age, your gender, your ethnic origin, your city, your state, your country, your industry, and so on. Pro tip: Avoid any organization promising to send you a book about the grants you might be eligible for or websites that charge you a fee to access a directory of same. A simple internet

search or a chat with your local chamber of commerce or economic development officer is all you need to get started.

3. Contests: Lots of business-oriented publications, websites, and vendors sponsor contests all the time. Depending on the prize and the requirements to enter, some of these might be worth your time. Just don't get too distracted by long shots requiring a heap of work.

4. Discounts: Always ask if there's room to negotiate a lower-than-advertised price on anything you buy. The worst that can happen is they say no; the upside is that you can apply the money saved to growing your business.

5. Rebates: These can sometimes be a pain to pursue, as the process for getting them is often deliberately heavy on the bureaucracy. If you're persistent and pay attention to the details of the process the first time around, they can be helpful.

6. Giveaways, support programs, co-op advertising: Your vendors have a vested interest in seeing you succeed. After all, if you stay in business, you're likely to remain a customer. Therefore, many have developed customer support programs that involve more than just answering your questions about their product. Offers might include training, coupons for partner vendors, a willingness to split advertising costs with you if you feature their product, and other freebies. Your account representative or sales rep might

not remember to tell you about these things or may not know about their availability in the first place, depending on how well-versed they are in their company's offerings. *Push them* to find out.

7. Tax credits: The absolute best thing you can do for your business and family is to get a competent and knowledgeable tax advisor. Ask them to find out what municipal, state/province/region, and federal tax credits might be available to you. If you can't afford one yet, do your own research and max these out.

Actually Take Those Baby Steps

We all have a tendency to think that we'll fix a certain problem "someday," when we feel that we have enough time, money, or brain space to deal with it. In the meantime, we remain stressed, either consciously or unconsciously, about this unsolved issue.

Taking action, even a tiny action, can have big benefits. First, you immediately get some stress relief because you're doing *something*. That can pay dividends in terms of your health and in terms of being less distracted and more able to focus. Second, you're chipping away at the problem, which is better than doing nothing.

Speaking specifically about money, two things will be a huge concern for you right now: either your debt or your lack of savings. Or likely, both! Here are three things you can do right now to start fixing these:

1. If you have debt, see if you can make more frequent payments against it. That is, if you typically pay $200 once a month, change this to $100 twice a month. This will slow down the interest piling up on it and potentially save you a lot of extra money.

2. Don't wait until you have a lump sum or that magical day when you have more cash coming in to either pay off debt or save for the future. Even if you can only do $5 a week, start an automatic transfer to put that $5 a week to work *right now*. Unless you're in truly dire straits, you won't miss $5 a week, and you can easily increase it later.

3. If the interest charged on your debt is more than the interest you can earn in a savings vehicle, concentrate on paying off the debt. If you have multiple debts, focus on one with the highest interest rate first, and work your way down the list. You can also shop around for a debt consolidation loan, as long as you're careful about not racking up new debt.

Some of Our Hacks

We were pretty aware of how to reduce expenses even before we went into business together. When we got married, we walked right past the "wedding store," where there were shoes in the window for approximately $400 (currently about $550 US), and got a lovely pair of shoes at

the department store for Chandra for £30 instead. Same style, same colour, same quality, much less markup.

Terry uses shaving soap instead of overpriced spray foam that comes in non-recyclable cans. Chandra avoids the "pink tax"[31] by using men's razors. We both use "mix and match" or "travel wardrobe" clothing styles, where a few pieces in a few different colours can be combined in various ways to give you a lot of variety at very little cost.

In business, we look at whether it's better to hire a skill or learn it. The answer is almost always to hire the skill. The time you spend learning to do a skill someone else has already learned (and typically has more experience implementing) is time you're not devoting to improving your business at the macro level.

The best money-saving hack, though? *Make yourself wait to buy something.* Put that big screen TV, professional knife set, fancy enterprise-level software on a wish list instead of whipping out the credit card. Go through a cool-down period. Every once in a while, when you actually have money to splurge with, revisit the wish list. Chances are, at least half the stuff on your wish list isn't that interesting now. Delete them. Stuff that consistently stays on your wish list is what you really want (or need) and will be a better buy than those other impulse-driven purchases.

CHANGING RELATIONSHIPS

 Avoid loud and aggressive persons; they are vexatious to the spirit.

— *Max Ehrmann*[32]

As if running a business and starting a family weren't hard enough, you also have to deal with a sea change in your relationships at this stage.

When you have your first baby, everything turns upside down. You have less time for your friends, at least at the very beginning, because it will be as much as you can do to cope with the demands of a hungry and seemingly tireless child. You'll also probably have less interest in the things you and your single or childless friends used to do together because you have a new wonder in your life. Frankly, they'll probably have less interest in you right now, too, because all you can talk about is baby cooing, baby diapers, and baby spit-up.

Your friends who are not entrepreneurs may not understand why you're so focused on your business to the exclusion of much else. They and some of your family members may even be chastising you for taking risks or pursuing what seems to them to be a silly dream. And as we already noted, money pressures can be a huge issue for couples.

Indeed, one of the hardest things about change and growth —and this is probably why a lot of people don't push for it

—is that it sometimes means you outgrow some relationships. This is natural, but it can also be very painful for both parties. There are some ways you can make this time of your life a little easier.

Go Zen, Again

It's important not to give up on relationships too easily; sometimes people just get busy through no fault of their own and they don't mean to drift away. Do keep reaching out if the relationship means something to you, and try not to take it personally if you think this isn't being reciprocated. Accept that sometimes, people take different paths in life.

Detox

On the flip side, now might be a very good time to assess any relationships that are doing you more harm than good. Raising a family and running a business at the same time is hard enough; having "toxic" people in your life can sink you.

Maybe it's the "friend" you have who really only ever calls you to complain about his love life (and never takes your advice, either). Perhaps it's a relative who criticizes your every move and maybe even actively works to undermine you.

Obviously, don't willy-nilly dump anyone who doesn't fit perfectly into your life, but do regular gut checks as to whether you're getting as much from the relationship as you put in, and that it's healthy. Gently remove the toxic

people from your life (you have a couple of excellent excuses right now!), or at the very least, start tapering off their access to you and their effect on you as much as possible. This can be super hard to do with close relatives (hello, The Guilt), so let's talk about how to do that.

Build a New Support Network

Even if you're an introvert by nature (and both of us are), you need at least a few friends whom you can count on.

- It's important to have at least *one person in your life with whom you can be honest.* If, for example, there is no one in your life to whom you can say, "You know what, I'm worried we won't make payroll next month," then you're going to have to keep that bottled up. That's not good for you, your family, or your business.
- There should be other *people in your life who understand your path* and may even be on the same path as you. This could include other couples with children, other single moms, or parents with special-needs children, depending on your situation. Now is the time to seek out groups that support entrepreneurs too. You might like the Rotary Club, or the Entrepreneur's Organization might be more your style. Maybe a co-working space would do the trick. Shop around until you find something that fits.
- There should also be *people in your life who aren't doing the same things as you are,* because

both of you can benefit from the diversity of each other's experiences. If you never look beyond your own situation, you won't grow.

- There's a saying: if you're the smartest person in the room, you're in the wrong room. A similar concept: you are the average of your five closest friends. In other words, if you aspire to greatness, *seek out people who are going to inspire and push you to be greater*, even if they're not actively mentoring you. (Be sensible about this, though: don't work yourself to death because your hero is a billionaire, and don't beat yourself up if you're not a unicorn startup within six months.)

Now let's move on to the most important relationship of all: your spouse or partner.

The Parable of the Glass Jar[33]

One day, a professor gave his students a powerful life lesson.

After everyone had filed into his lecture hall, the professor said, "Okay, time for a quiz." Instead of handing out papers, though, he pulled out a very large glass jar and set it on the table in front of him. He then produced several very large rocks and carefully placed them into the jar.

When the jar was filled to the top and no more rocks would fit inside, he asked, "Is this jar full?"

Looking puzzled by the question, everyone in the class nodded and said, "Yes."

"Really?" the professor replied.

He reached under the table and pulled out a bucket of gravel. He tipped some gravel in and shook the jar so that the gravel worked into the spaces between the big rocks.

He then asked, "Is the jar full?"

"Probably not," one of the students answered, smiling.

"Good!" he replied.

He reached under the table again and this time, brought out a bucket of sand. He poured the sand into the jar, and it went into all the spaces left between the rocks and the gravel.

Once more, he asked, "Is this jar full?"

"No!" everyone replied, enjoying the game.

"Good," he said.

Then he grabbed a pitcher of water and poured it until the jar was filled to the brim. Then he looked at the class and asked, "What is the point of this?"

One student at the front raised his hand and said, "The point is, no matter how full your schedule is, if you try really hard, you can always fit some more things in it!"

"No," the professor replied, "that's not quite the point. The truth this illustration teaches us is this: if you don't put the big rocks in *first*, you'll never get the rest in at all."

The big rocks in this case represent your spouse or life partner. This is your single biggest relationship investment, and it's no exaggeration to say that he or she will be critical to the success of both your business and your family.

You should NEVER take this relationship for granted. Unfortunately, it's also one of the easiest relationships to let slide, especially in the hurly-burly of everyday business operations and raising kids. Worse, it's easy to let little slights, irritations, and annoyances build up over time until they become a big pile of resentments or issues, which you'll naturally drag out when a genuinely big and important issue needs to be discussed.

We can say that our relationship is easily the most important factor in our success. We recognize that, and so we consciously work on it nearly every day.

This is one area where you *do* need to sweat the small stuff.

"Date nights" are a good place to start. We routinely set aside a night every couple of weeks or so where it's just the two of us for dinner and a movie. More often than not, even though we're now in a position to afford better, this is dinner at home and a movie rental after the kids have been fed and packed off to bed. This is simply because it's much easier to arrange this than a night out involving a babysit-

ter, and so we're much more likely to do it: the time together is more important than the venue.

We've tried to make these date nights free of talk of the business or the kids, based on the advice of other successful couples, but inevitably, that stuff creeps in. And why not? The business and your children *are* your life, and if your house is anything like ours, these dinners together are probably one of the few times you can start—and finish—discussions without being interrupted a million times by kids, pets, customers, parents, etc. So, try to talk about other things as much as possible, but don't worry about it if the conversation swings back to its natural centre.

Another very important aspect of your relationship is physical contact outside of sex. Hold hands. Sit close on the couch. Give your partner a smooch before he or she goes somewhere, even if it's just to the store on a milk run. And hug. A lot.[34]

We all know you need to actually say "I love you" in a relationship. What many of us forget to do is say "thank you." It's pretty much impossible to say this too often, and it's especially powerful when you don't *need* to say it. For example, it may be that the division of labour at your house has naturally fallen into a pattern where you always make the bed and your partner always takes out the garbage. You're both doing a job that you've always done, but it's very, very nice to hear a thank-you for that every once in a while. It means that the effort is noticed and appreciated, and who doesn't want to hear that?

You should work to protect each other's mental health, too. Make a pact with your partner to keep tabs on how you're both doing. Offer up things like favourite drinks or nibbles unsolicited. Shoulder rubs. Hot baths. Take the kids for a bit and send them for a long walk. Whatever helps to keep relationship pressure or stress from building to the point where you're snarling at each other. Or if you want another analogy, think of your relationship like a savings account. Every time you make a deposit, the account grows, and you also accrue interest. You'll have that account to draw on when *you* need it.

If you and your life partner work together, it's not a bad idea to have one or two hobbies or activities that you do separately. Terry likes model railroading. Chandra plays casual games on her iPad. We all need a bit of "me" time. Conversely, if you work separately, a joint hobby—providing it isn't a competitive one—might be an opportunity to bond.

Children Are People Too

The world is full of entrepreneurs (and celebrities and politicians) who are astronomically successful. Tragically, many of them also have children who end up with drug or alcohol problems or in jail or estranged. Or worse.

Now, it's definitely true that parents only have a limited amount of influence on how their children turn out. Kids are not blank slates, and there are thousands of factors that shape who we become.

But to the extent you can mould your children, you want to be a present and positive influence on their development. You do not want—in five, ten, twenty years—to be saying, "Wow, I won in business, but my kids' lives have been wrecked in the process."

The easiest way to prevent this is to know when to say "when." Know when to be satisfied with your accomplishments—daily, weekly, monthly, yearly. Set aside the business and *be* with the kids. Turn off the phone, step away from the computer, come away from the shop. You don't have to be a "helicopter parent" hovering over their every move, and certainly don't spoil them. You also don't want to be a "shirtsleeves to shirtsleeves in three generations" type family.[35] But you do have to nurture them as you would your business or your other relationships.

- Schedule regular one-on-one time with them. Make sure you do stuff *together*
- Enjoy board game nights
- Watch movies on Saturday afternoon (even if they choose Frozen ... *again*)
- Eat together regularly, with no devices or TVs going
- Share your favourite things with them, and let them share their favourite things with you
- Do the things you wished your parents had done or, if you had great parents, try to replicate that for your children
- Listen to them; *teach* them. Don't expect them to

just magically grow up and absorb things by
osmosis

The clichés are clichés because they are true: "Children *are*
only young once." "You only get one shot at this." And one
more: "The days are long but the years are short."

You had kids for a reason. Honour that.

Self-Care

Work, friends, relatives, spouse, kids ... But what
about you?

We tend to live in very selfish, narcissistic times. Think:
the prevalence of the selfie, the barrage of commercials
encouraging you to indulge yourself in any number of
luxuries, the pressure of social media to showcase yourself,
etc. It's no wonder some members of previous generations
regard us with a raised eyebrow.

But as much as we've come to dislike some of the
messaging behind "me time," there is a kernel of truth in it:
we need *time* for ourselves. *Stuff* is not a substitute for
time. So let's talk about your relationship with yourself.

How long has it been since you looked in the mirror—
either literally or figuratively—and said, "Self, howya
doing? No, really?"

As entrepreneurs, we want to project confidence, decisive-
ness, and competence. We're leaders and people of action.
We're busy, busy, busy, and we have 1001 things on our

plate. We like phrases like "crushing it" or "massive action." And everything is fine! Right up until it isn't. And then *whammo!* We have a crushing case of the flu or a massive case of burnout.

Look, you probably wouldn't let your car run for tens of thousands of kilometres without maintaining your brakes and tires, right? Why wouldn't you give yourself the same care and respect?

Schedule time off. *Real* time off, where you're completely unavailable. We know, we know, that's *super* hard to do when you're in the Startup phase. A week-long vacation with no contact might be out of the question right now as you're building the biz and working on documenting stuff so you can hand it off.

So start small. Maybe it's just for fifteen minutes in a hot shower at the start of your day. Indulge in your favourite cup of tea midafternoon with the door closed and the phone off. Read fiction. Watch your favourite half-hour or forty-five minute TV show once a day. Make sure you're completely unplugged from the business.

Work your way up to a whole day off once a week. Make sure your life partner and business partner support you in this, and make sure you guard their recharge time, too.

If you're lucky enough to have staff at this stage, insist they take their vacation time, even if they're workaholics. Not only is it the right thing to do, but happier, more relaxed

employees are more productive and they also make for happier customers.

Don't put off time off until you can afford it, time or money-wise. You can't afford *not* to.

Take Off Your Hats!

Here's another confession: we waited far, far too long to hire help.

We started Scribendi in 1997, and while we had copy editors working for us from the start, we didn't hire anyone to help with support services until 2005. That's a *stupidly* long time to be doing everything on the backend ourselves.

Like most new business owners, we were afraid to take what seemed like such a big step. Did we have enough work in that one area to justify a hire? What if we couldn't make payroll? How do you go about hiring someone anyway? How do you find someone you can trust? And what if you have to fire them?

And yet, the business didn't really start ticking along until we started "taking off hats," so to speak. The first thing we hired out was bookkeeping and filing. Part-time at first, and then full-time as we got busier. Why bookkeeping? Because businesses are ultimately run by the numbers, and the more accurate and up-to-date your numbers, the better your decisions. Plus, it was our least favourite, most time-consuming activity.

Once we started taking off those hats, we started making more money. Why? Because we were freeing up our time to do what we did best: think up new ways to increase revenue. As more money came in, we hired out more roles. Wash, rinse, repeat.

Your First Employee

If you're hiring an employee, as opposed to contracting a freelancer or outsourcing to a service, there's a lot more to it than just shaking their hand and handing them a paycheque occasionally.

You'll want to consult local labour laws before you even advertise the position. You'll need to know the market rate of pay for the position you're going to hire and what health and safety measures need to be in place. You learn how to conduct an interview fairly and to ensure you aren't discriminating against candidates for reasons that have nothing to do with their abilities.

You should also have a think about the policies you'll need to have in place to prevent things like workplace harassment. In fact, having an employee handbook—setting out expectations on things like behaviour, dress code, attendance, and so on—is highly recommended.

When you do find the right person, it's a good idea to keep a record of what things they have access to. Did you cut a set of keys for them? Do they have access to the cash drawer? What equipment do they need to use, and what can they take home?

Phew! Does that sound like a lot? It is. Especially when you're first getting started. But this is something you really, really want to get right. You don't want to have an employee get hurt on the job because you didn't tell them they shouldn't wear jewelry; you also don't want to get tied up in a lawsuit for something like wrongful dismissal or having a hostile workplace.

Fortunately, there are a lot of resources available online. For instance, you can purchase and download region-specific handbook templates (make sure they're prepared by actual human resources professionals), and your local government or economic development office will be able to provide a lot of advice as well. If you're really nervous, you can usually engage an HR firm on an as-needed basis until that wonderful day when you have enough staff to warrant hiring an HR manager in-house.

Back to You

You can start by making a list of vital business activities that you hate doing and that take up a lot of your time. Then, do a gut check: are these truly vital business activities? For example, are you spending a lot of time making videos for whatever the coolest vid app is right now? Is that where your customers are? Are you generating any revenue with that? What's the long-term strategy?

Once you've reassessed everything, pick the activity that will give you the biggest bang for your buck. As you saw, for us it was bookkeeping. For you, it might be inventory management.

Then, clearly define the role. Exactly what will this job entail?

Next, decide how you're going to hire out the position. Is this a job that could be done by a virtual assistant (VA) with a minimum of supervision? Is it a part-time position? Full-time? Do you have policies and processes in place for them to follow? Have you set aside the time to train them, or do you have another staffer who can?

Check out the workbook for a cheatsheet you can use to assess a job.

1. Lots of numbers get thrown around on this; an Internet search suggests failure rates might be as high as 90% in that critical first year. Ouch!

2. Terry is originally from England. As a joke, on his first flight to Canada, Chandra handed Terry a Canadian dollar and quarter so that, when we'd "made it," he could later claim that he came to this country with just $1.25 in his pocket.

3. Psst: Ecosia.org is a search engine that works just about as well as that other one and they will plant trees using the money they earn from searches and ads. We're not affiliated in any way. We just like trees.

4. A house we refer to as "the house that shall not be named" because we hated that place so much. For a comparator, check out Tom Hanks and Shelley Long in *The Money Pit.* Not even joking.

5. For the Americans reading this book, that's colder than six football fields.

6. Corollary to this: make sure your calendar is backed up or on the cloud or whatever. You *do not* want to become one of those people who has a breakdown because they lost their phone and, therefore, their life.

7. Or Norman Vincent Peale, or Mary Kay Ash, or... this is one of those quotations that seems to have varied origins, and/or versions of it

have been floating around for centuries. Even Virgil had a version of it. ("Possunt quia posse videntur.")

8. Chandra has this theory about kids and energy levels: the reason why they are so bouncy, particularly when you're so tired, is because they're actively draining the energy *from* you through some space-time-continuum wormhole thing.

9. This is why the advice "sleep when baby sleeps" is so laughable, right?

10. Side rant: for the love of all that is holy, if you're a software provider, sthaaaap making people call to arrange a demo or just to find out your pricing. Put it up—all of it!—on your website. You aren't making any more sales by forcing people to interact with you; indeed, you're just wasting your sales team's time by making them to talk to people who are just in the interest phase of searching. And in fact, you're probably *losing* potential customers because, from a customer's point of view, having to carve out time for a *sales pitch* is ... repellent.

11. Another reason why we will always prefer emails to phone calls. Emails provide a "paper" trail you can refer back to when push comes to shove. Documentation for the win!

12. Third child's the charm though, in case you're wondering. It got easier from then on—which is weird, because at this point you're outnumbered by your children.

13. If you already have toddler-aged children who are addicted to the *Frozen* movies, you may have sung this last bit in your head. Sorry about that.

14. As some wiseacre once said, "The flu is simply Mother Nature's way of telling you to slow down." Thanks, Mother Nature.

15. To be clear, there's nothing wrong with ADD or ADHD, any other kind of neurodivergence, or indeed, being proud of your neurodiversity. We're talking about casual use of the acronym in a way that isn't helpful.

16. Consider turning off notifications for all your apps and programs, too. As in, permanently. They're explicitly designed to pull you away from what you're doing!

17. At one point, there were two identical bears, so that one could go through the wash without too much fuss, and there wouldn't be a meltdown if bedtime bear did go wandering somehow. However, at some point, we were busted and then *both* bears had to come to bed at the same time. Your mileage may vary.

18. If you get nap times. Ours stopped napping at about eighteen months. Every. Single. One. Of. Them. And none of them slept through the night until about year old either. Sigh.

19. If yours do before then, count yourself very lucky. Also, we hate you.

20. Chandra has never signed up for a Tough Mudder competition. She figures that with four kids, she already is one.

21. Terry does not understand this exercise trend, as there's not a lot of call for heaving tractor tires around in real life.

22. There are countless self-proclaimed diet and fitness experts out there who cherry pick studies to support their claims. Our rule of thumb here is to avoid any plan that requires you to buy special food or special equipment, especially if they just happen to provide it.

23. Chandra in particular has sucked at this sort of thing since high school. Prepare a lunch the night before? Bahahaha.

24. And/or our partners, spouses, kids, staff …

25. Chandra maintains that breakfast meetings are a scourge.

26. Another quotation with multiple possible origins.

27. Which reminds us: those pictures of passive income entrepreneurs or Internet marketers and their luxury cars? Big fancy houses? A lot of those are staged. The car is a rental or borrowed. The house is a place they've parked near for a quick picture. Not all of them, but let's just say there's a *lot* of the "fake it till you make it" types out there.

28. We previous noted that we have electric vehicles these days. There are few things more satisfying than driving *past* the gas station.

29. Espresso con panna, just in case you ever feel the urge to buy us one.

30. Biiiiiig footnote: Be very, *very* careful about how you do this, however. First, check the terms of your employment. You may find you are not permitted to moonlight in any way while employed by that company, or that anything you create during your period of employment belongs to the company—even if you did it on your own time. Definitely do not do anything that remotely infringes on the company's intellectual property, competes with your employer, or creates any other kind of conflict of interest. And of course, don't be doing stuff for your business when you're on company time. Finally, watch for the time frames associated with your contract. Just because you quit a job doesn't mean you're in the free and clear; contract terms, especially non-compete and non-disclosure terms, will often extend past your resignation date. And by the way, we're not lawyers. You should definitely consult with one.

31. Pink tax, you might ask? It is often the case that products marketed to men are cheaper than products marketed to women, even when they're made from the same material and are the same quality. Razors, deodorant, shampoo, blue jeans ... just a few examples.

32. This is from a piece entitled "Desiderata," which is worth checking out it its entirety.

33. This one has multiple titles, and has also been called the Rocks, Pebbles, Sand story.

34. This can be hard to do if you grew up in a house without many PDAs—public displays of affection. But hugs are good for you *and* society as a whole, so make the effort! Check out Paul Zak's TED talk on trust and morality.

35. In case you haven't heard of this one: the first generation struggles to build a foundation, the second generation expands on it a bit, the third, having grown up with too much privilege and wealth, ends up squandering it all. Back to square one.

THE GRIND

So, you've survived your first year in business. Congratu-lations!

Seriously, that's a real achievement. As we noted in the previous chapter, not many businesses make it past that first year. Whether you made it past the post by the skin of your teeth or you sprinted past easily, you've still done more than something like ninety percent[1] of all attempts at running a business.

Now comes what we've not-so-lovingly dubbed "The Grind." This is the slow ascent, where you're scratching and clawing your way to every milestone. We're going to have to approach this stage differently than we did the Startup phase.

The Grind is, well, exactly what it sounds like. Not very much fun. You're kind of over the "excitement" part of

Startup and you're slogging along. At home, you're also kind of over the new parent aspect of having kids. You might have a second or even a third child, and you're no longer logging every diaper change or feeding time or photographing Every. Single. Moment. Not because you don't love them as much, but because, honestly, you don't have the time!

Before we get into specifics, let's talk about two major mindset shifts you'll need to make to survive The Grind.

Beating Yourself Up

First, stop beating yourself up for what you're *not* accomplishing.

There's a reason why your to-do list seems endless. It *is* endless. Because you keep adding to it!

At work, if it's not one crisis supplanting another, it's the stream of awesome ideas you keep coming up with to improve the business.

At home, you're just nicely past the diaper stage with child one when child two comes along. Or maybe everyone is potty trained, but you have one child constantly challenging you or getting into mischief. Perhaps your kids are angels, but your parents are being incredibly frustrating and challenging.

So, stop measuring your progress against the infinite scroll that is life. That's a recipe for feeling like a failure. Always, always focus on what you *have already done.* Where did

you win today? This week? This month? How about this year?

There Is No Promised Land, Sorry

Second, stop thinking in terms of "well, once we get past X, we'll do Y." Or, "things will be better once we're past this stage, so we'll wait on Z until then."

Accept that you will *always* be exchanging one set of issues or problems for another. There is no golden era of trouble-free existence, so if you're waiting for one before doing something, well, stop waiting. It ain't coming.

Now, let's get onto some specifics. First, we'll revisit our old friend The Guilt.

WHY AM I UNHAPPY?

We don't just need to work. We don't want to work. We *love* to work. We say things like *workaholic* and *too busy* like they are good things. But sometimes, especially during the Grind phase, we quietly admit to ourselves that sometimes this stuff we're doing is actually rather BORING, and no, everything is *not* awesome.

In fact, we're exhausted and cranky, thank you very much.

Let's be honest, *Sesame Street*®, or whatever your kids are into at the moment, isn't exactly mentally stimulating. And let's also be honest and say that not every single moment with your child is going to be fulfilling. There will be frustrating moments ("Another tantrum? Really?") and disgusting moments ("He barfed *where*?") and terrifying moments ("Hello, Emergency Department—my old friend!"), but preciously few fulfilling, chilled-out moments.

It's especially important for women to take this on board about motherhood. From day one, women are taught that Being a Mother Is the Best Job Ever. It can be. So can fatherhood, but in either case it's *not* the best job ever one hundred percent of the time. Lots of it is just pure struggle. Potty training. Being a referee between siblings. Enforcing rules. Repeating yourself endlessly.

The Guilt we feel at this stage, which is usually on top of The Guilt we talked about in the previous chapter, comes from our lack of happiness.

We have a business. We have a family. Other people are beginning to look at us with envy. We seem to have it all? Why are we feeling so ungrateful about it all?

What's *wrong* with us?

Nothing.

Nothing is wrong with us. It's okay to say that not everything you do at work or at home is fulfilling you. It's okay to say that sometimes everything sucks and that yeah, you have it better than a lot of people right now, but that doesn't make it feel any easier.

Embrace it. Own it. Then, either let it go or do something with it.

Letting it go frees you to get on with what you need to do. Wallowing in guilt is not productive or healthy, and it erodes your self-confidence.

Doing something with guilt motivates you to do better. Just like feeling guilty about not spending enough time with your kids *should* motivate you to spend more time with your kids, feeling guilty about not appreciating how good you do have it should motivate you to seek reasons to be grateful. Count your blessings regularly, and we promise you'll feel better about everything.

SO MANY MISGIVINGS

The only thing worse than Startup doubt is Grind doubt.

You've made it this far, and now you're pushing hard uphill. You truly understand the nature of the phrase "a Sisyphean task." This is the blood, sweat, and tears phase, for sure. And because everything feels so darn hard, you're not sure if you got here by cunning and wit or pure blind luck. If you're so smart, shouldn't this be easier by now? Even a little? You wonder constantly if it's all going to come crashing down.

Imposter Syndrome rears its ugly head. Do I have the slightest clue as to what I'm doing? They're all going to laugh if I fall flat on my face here, aren't they?

At this stage, you might even have more worries: the welfare of your staff and their families. If you fail, they go down with your ship.

Worse, you have the media and maybe friends and family tut-tutting at you about work/life balance. And how you're going to die if you don't get enough sleep. Because nothing helps you drift off faster than worrying that you're not getting enough sleep, right?

Here's the thing: everyone talks about work/life balance, but hardly anyone describes what that's supposed to look like. The impression you get is that it's about rising gently from your bed, refreshed, powering through your day fuelled by nicely timed, healthy meals, then some quality time with the family, perhaps a workout, followed by a nice glass of cabernet sauvignon and a book.

Bahahaha. *Bahahahaha!*

Perhaps your day looks like that if you're a billionaire and can afford lots of domestic staff, but for the rest of us, work/life balance is really about averages.

Yes, *averages*. You're not aiming for daily perfection here. That's a good way to sign up for failure. What you should try to do is make sure you're reasonably balanced over the course of a week, or maybe even a month.

Have a crazy work week? Average that out by chilling as much as possible on the weekend. Are your mornings completely bonkers because you have to get everyone out the door on time? Do what you can to make the evenings a bit better.

At a political fundraiser once, Chandra found herself admiring the resume of the keynote speaker. Mother of four (maybe it was five?) kids, a PhD, powerful position within the party, and so on. How the heck had she managed all of that? Chandra decided to ask her. The answer?

"You can have it all. Just not all at once."[2]

It was a short answer, but a powerful one that reminds us once again to pace ourselves. We'll get there.

TIME ONCE AGAIN

If we thought we were short of time before, little did we know! At least the kids occasionally had naps!

And the business had (scary) quiet times. Now it's Go! Go! Go!

We're always "on call" as a parent and as an entrepreneur. It's exhausting.

We noted before (Take Off Your Hats!) that we waited far too long to hire staff at the office. If you haven't read that section yet, go back and do that now, because now we're going to apply that same principle at home.

Make a list of all the routine stuff you do that gets in the way of making progress in your business, spending time with family and friends, or just chilling out. Because if you have any money or process invention time to spare, you're now going to invest it in: you.

If you're stuck for where to start, here are some things we either hired out, delegated, or streamlined/automated in our house:

1. Bill payments. If your paycheque(s) hit your chequing account on a regular, dependable schedule, consider switching as much as possible to pre-authorized payments. Don't forget to set yourself a reminder to actually check that everything is functioning as it should once a month.

2. Parcel reception. We live on a rural route, which means we get our post delivered to a roadside mailbox. It was smallish, so we were constantly getting pickup notices from the post office to

retrieve a parcel from the main office in the centre of town. We invested in an oversized mailbox and cut the number of trips we had to make to nearly zero. Your issue might be porch pirates swiping your deliveries. Whatever it might be, how can you simplify your life?

3. Lawn mowing. When we were super busy, we hired this out. Since then, we've converted a huge patch of our lawn to wildflowers,[3] and our teenaged kids deal with the rest with an electric mower.

4. Housecleaning. Every once in a while, we splurge on a super-deep cleaning of the house. You may wish to hire someone in more often.

5. Kids and chores. We're big on children doing chores, and not because it means we don't have to do absolutely everything.[4] We felt it was important that the children feel like they're contributing to the household and learning how to be self-sufficient at the same time. Our expectations are tempered by their age and skill level, and we started them off on simple stuff when they were around four (e.g., making their own bed). By the time they're ready to go to college, they'll know how to do everything from laundry to cooking a decent meal.

6. Renovations. Is there any aspect of a job you could hire out? When comparing costs, don't forget to consider the cost of tools and equipment you'd need to do it yourself (and which generally

sit around gathering dust in your garage ninety-nine percent of the year, unless you rent them).

You might balk at spending money on stuff you know you can do yourself, especially at home. And there's certainly value in doing hands-on work, especially if your business is mostly white collar/mental work. It's a good way to stay grounded and give your brain a break, in fact.

On the other hand, what's the opportunity cost? How much is your time spent moving your business ahead worth? What's the price tag on your mental and physical health? How much do you value your relationships?

If you're still broke or have very little cash to spare at this stage, consider bartering with friends and relatives. A friend of Chandra's found ironing very relaxing, while Chandra enjoys cooking, especially fancy dinner gatherings. Why not trade stuff you don't like for stuff you do?[5]

BEST PRODUCTIVITY HACK EVER

By far, the best time-saver or productivity hack we've ever come across, however, is the three-item list.

You take one piece of paper, maybe a sticky note, and write your top three "to do" items for the day.

That's it.

What's the catch? You can *only* put three items on it.

Here's why: *three* forces you to prioritize the most important stuff. And *three* is (almost always) achievable in a day. That last part is critical because human brains are weird. If you cross three things off your list in a day, that's a one-hundred percent success rate. Yay! If you cross off eight things on your ten-item list, that's "only" an eighty percent success rate. Which to the even weirder high-achiever entrepreneur brain feels like failure.

Of course, if you get your three-item list done early in the day, you can always do a few more things, as long as you're not tallying them against a list. Then they feel like bonus achievements.

Yeah, we know. Not very rational sounding. But it works. It's all in how you frame it.

HEALTHIER AND HAPPIER

The Grind is just that... a real grind. It can wear you down fast, and even if you think you're coping, burn you out even faster.

Your first defense against this is to schedule more time off. And yes, leave work earlier than you have been doing. We know this is counterintuitive. It feels like the answer to having a lot to do is to work more hours. But guess what? This is actually the *opposite* of what you should do. We refer to this as the Law of Diminishing Returns.

As you get more and more tired, it's harder and harder to focus. You can't make decisions quickly, and you're more

likely to make bad decisions. You doubt yourself more. Your movements are slower. And that gets exponentially worse as time goes on.

Think of it in terms of percentages. You're probably good for about four to six hours at a hundred percent focus and effort. But after that final peak hour, you're down to about fifty percent. The next hour, twenty-five percent. Then twelve, then six, then three percent.

Do the math now. After your peak, you've spent five loooong hours to accomplish about ninety-six percent of one hour at your best. And now you feel like crap to boot.

Blergh. Not a good use of your time. Leave it, if you can, and come back when you're fresh.

THE PROVERBIAL CANDLE

Terry is an early riser. Chandra is a night owl.

What this meant for a long time was that we were up late *and* up early. Burning the candle at both ends. This led to a lot of crabbiness, especially from Chandra. This was compounded in the early years of our marriage by kids being up at night, and more recently, chronic insomnia for Chandra.

Good times.

And of course, as entrepreneurs and parents, our brains are constantly buzzing. Ideas, worries, plans, concerns. How the heck do you turn down the volume on all of that?

We haven't found any silver bullet yet, but a whole raft of things has helped. These include:

1. Consistent bedtimes and wake-up times, even on weekends

2. Getting away from screens at least an hour before bedtime

3. Stopping taking in caffeine by midafternoon at the latest, and go easy on the alcohol. While alcohol makes you sleepy, it gives you a crappy sleep cycle and often weird dreams as well

4. Do a brain dump of all the things in your head every night. Write it all down. That helps tame monkey mind.

5. Read fiction! Quite apart from the fact that Chandra also writes fiction and would love it if you bought her stories, fiction is an awesome way to disconnect from your day. Unwinding, letting your subconscious chew on things for a while, living vicariously through the characters of the books—all these things provide relaxation and amazing insights.

6. When you read business books, save them for when you are travelling. It's a good use of waiting time (once you've seen one airport lounge, you've seen them all) and because you're out of your usual environment, you'll be primed to consider new ideas. There *is* something about travel that makes us more receptive than we otherwise might be.

STRESS LEVELS SET TO MAXIMUM, CAPTAIN

Stress in the Grind stage is a strange animal because it's a hybrid. There's *bad* stress and there's *good* stress.

The *bad* stress comes from feeling like you're constantly putting out fires, behind on your task list, or beholden to everyone: customers, staff, partners, kids.

The *good* stress comes from your head constantly whirling with ideas, plots, and schemes. And also the sensation of "Whee! It's working! Sort of!" Kind of like when you ride a bike without training wheels for the first time. Exhilarating and terrifying because you're not quite sure how it's all working and you don't know how to bring it under control.

Both kinds of stress stem from … that feeling of lack of control.

To deal with the good stress, we set up a "Wouldn't It Be Great If …" project board, where we dumped all our ideas for improvements and changes. This was enormously helpful for a number of reasons: it got the ideas out of our head, which gave us more bandwidth; it made our ideas transparent to staff, so they could see what we were contemplating; more importantly, it allowed us to pause and consider all of our ideas in the context of the bigger picture and, especially, long-range plans.

Rather than just leaping on the first great idea we had, we could consider what was doable in the short term and would have the biggest impact, but that wouldn't mess up

future plans. We saved ourselves a lot of time and money on distractions and backpedalling.

To deal with the *bad* stress, we would periodically try to get away from our business. As in physically away. There's something about being someplace else (and ideally, disconnected from the electronic tether that is your smartphone) that allows you to gain a bit of clarity. This tends to work better if you can be gone for longer than twenty-four hours and be in someplace unfamiliar. We call this "getting the thirty-five-thousand-foot view."

The name is a reference to travel but also the idea that you need to zoom out to see the whole picture. When you're physically *in* your business, you're dealing with what's right in front of you, and you don't have the time or the energy to think more broadly. Putting yourself in an unfamiliar environment is also nicely distracting, which allows you to shove your current concerns into your subconscious for a while to percolate.

If you don't have much money for travel, consider doing something on the cheap, like visiting friends or relatives you haven't seen in ages, even if it's just for the weekend. If you'd prefer not to do something carbon intensive, or if travel options are severely curtailed like they were in 2020, there's always a hike in the countryside. Fresh air, a bit of light exercise ... What's not to like?

PROTECTING YOUR SUPERPOWER

We don't know if decision fatigue is actually a real thing, but it certainly feels like it on some days. Since your superpower is your ability to decide, you might want to find ways to conserve the energy you need to fuel that superpower.

Among other things, Steve Jobs was famous for only wearing black turtlenecks. It became his trademark style, but it also certainly simplified the decision about what to wear every day. Would this work for you?

It also used to be quite common for families to have the same meals all the time: Monday was spaghetti, Tuesday was meatloaf, and so on. This was usually done for budgetary reasons, but it also reduces the number of decisions you have to make. If a weekly meal plan doesn't appeal, perhaps a monthly cycle would provide enough variety? What about just making sure you have a ready supply of staples that can be combined into just about anything?

What business decisions can you simplify? Are you constantly having to guess when to restock an item? Can you take a look at how often you've had to restock in the past and get an automatic standing order set up? A subscription service? Is there software for your industry that will help you with this? Or at the very least, a calendar reminder that just tells you it's time, rather than having to check and decide?

MONEY TALKS

At least some money should be coming in at this stage. Your mission, should you choose to accept it, is to make it linger just a while before flying back out the door. Make it work for you!

It's time to think unconventionally again. Can you sock a little of your profit[6] into low-risk income-bearing investments, like dividend stocks, bonds, REITs? Do you see a lot of cash come in and out of your business? Are there any banking products you could use to earn interest on that (e.g., some banks do have interest-bearing checking accounts, for example)? Can you deduct interest *costs* on your taxes for anything?

As always, keep it simple: you don't want to be distracted by having to manage a portfolio as well as running a business, nor do you want to be constantly refreshing a news site to watch stock tickers all day. (This is not only unproductive, it does terrible things to your stress levels.) Use a set and forget strategy, use a robo-advisor or something like it for smaller portfolios, and pick boring, steady investment vehicles.

When it comes to where to spend the money at work, always reinvest the money in things that will make your operation more efficient. Your rule of thumb should be *better*, not *prettier*. Are there processes, software, or machinery that you've been babying along that could use an overhaul? Don't upgrade for the sake of upgrading, and

for goodness sake, don't let the sales rep talk you into an enterprise version of *anything* unless you really, really need it.

A good place to start looking for improvements is your staff. No, don't fire people—ask them questions! Find out what they absolutely loathe doing, what they find tedious, what they wish they could spend less time on. Ask them what they wish they had more time for. If you work to eliminate or at least improve the boring bits of their job, they'll be happier and more engaged.

Incidentally, that last tip is *the* difference between being "the boss" and being "a leader."

At home, you can make improvements to your finances by maximizing offers from various companies. For example, we made huge progress on a mortgage because we found a special mortgage deal. The company we got our mortgage from counted the balance of our chequing account against what we owed on our mortgage. Here's how it worked: say we had a mortgage of $200,000. When our paycheque (say it was $5,000) hit the chequing account, the company only calculated interest on $195,000 of the mortgage. This may not sound like much, but in the early days of holding a mortgage, when the interest is all frontloaded, it can add up to substantial savings. (Of course, with this type of product, you need the discipline not to borrow the money all back again and undo your progress, so be careful!)

Likewise, we picked a credit card reward program that worked specifically for us. With four kids and two dogs,

our grocery bills can be substantial.[7] Instead of getting a credit card that offered points for a piddling amount of air miles or in exchange for gadgets we don't really need, we got one that offered grocery discounts. Because we pay off our card monthly, and we run our big planned purchases through the card as well, we earn a lot of points and don't pay any interest. This cuts our grocery bill by as much as twenty-five percent!

CAN YOU RELATE?

By now, you probably have some staff. Who works for you?

No, really, who *are* they? Do you know anything about their home life? Their aspirations? Their likes and dislikes?

As far as possible and as far as is appropriate in a professional context, take a genuine interest in the people that have signed up to work for you. You don't have to be their best friends, but do remember that they're *human beings*, not robots or wage slaves.

We shouldn't have to put this in writing, and yet ... we can't tell you how many times we've wanted to beat our heads against a brick wall because we've heard that a company has decided to lay off staff *right before Christmas*. Or something equally heartless. Or worse, done stuff that is flat-out illegal. Yes, you have a business to run. No, you're not operating a charity. But you don't have to be Ebenezer Scrooge, either. Be reasonable. Heck, be *nice*.

If you're lucky enough to have grown to the point where you can't possibly get to know everyone, make sure your managers have solid relationship skills (and that you lead by example and have good relationships with the managers). Build a company culture that you'd feel happy in if you were an employee.

The sort of culture you build will depend on your business. If you run a quiet editorial firm, which tends to attract introverts with an eye for detail, rah-rah team-building events like noisy parties and extreme sports retreats are probably not a good idea. In fact, the very idea probably gives your quiet types the heebie-jeebies. On the other hand, if you run a sporting goods store, encouraging a company team entry in a local fundraising triathlon might be a winner.

How do you know what would work? Ask! The reason why team-building events generally get eye rolls and are considered cringeworthy is that they're typically *imposed* on people based on management's perceptions of how things *ought* to be. There's nothing wrong with something that will stretch your staff a little, but make sure you're not making them uncomfortable or stressing them out for no reason.

Some winners for our company were monthly potlucks, a wine tasting night, an escape room trip, and a cooking class.

This leads us to the first principle of good relationships at work: communication. And make sure it goes both ways.

Ask your staff what needs fixing and what could be improved. (Don't forget to explain your decisions on what gets fixed and what doesn't so they know you're not ignoring the feedback.) Ask them if they want to celebrate individual birthdays or just get a general catered lunch once a month to give everyone a break from brown-bag meals. Have (short![8]) monthly meetings and have everyone say what's going on with what they're looking after.

There's a reason some platformer video games have what's called a "final boss," a super-tough, annoying creature you have to defeat to progress. You don't want to be a boss or be perceived as an antagonist. You want to be a *leader*, and leaders learn, change, and adapt.

Transparency is also critical. Tell your staff *why* a policy exists, and give them a chance to shape it as the company evolves. Give them a heads-up as to what might be changing soon and why. Share the big picture. Show them the financials. Nobody likes to be treated as though they are a mushroom (kept in the dark and fed you-know-what)!

Oh, and put yourself in your employees' shoes. As in, actually do their jobs for a while. If you can't because you don't have the skillset (e.g., you're not a programmer or an engineer or something like that), job shadow them. Be sure to do it with a learning mindset and not a critical one. A thorough understanding of what your staff do and how it works within the organization you're building is key to making your staff feel appreciated, and it will help you make better

decisions when it comes to resource deployment or changes in procedures.

Happy employees make for happier customers, which in turn makes your life easier too.

ON THE HOMEFRONT

The Grind is the second most dangerous time for personal relationships (the first being Startup). Money is still tighter than you'd like, you're maxed out on work hours, and your kids are probably Going Through a Phase. (We can say this with confidence because kids are always going through phases.) You are being stretched ... possibly to a breaking point.

This is where you need to make use of every relief valve you can find.

Entrepreneurs tend to be an individualistic bunch. We like to believe we're self-sufficient and that we have supernatural stamina. And to a large extent, that's true. We can definitely put in the hours.

What we suck at is asking for help. This is when you need to get good at that.

Now is the time to get babysitting from trusted friends and relatives, or to pay for a good babysitter for a night out, even if it's just for a ham and cheese sandwich picnic somewhere. It's a great time to accept the invitations to dinner because it means you don't have to cook. If you have

buddies who are willing to help you with renovations, friends who are happy to help with odd jobs or cleaning for the price of a couple of beers and some time to shoot the breeze, take the help. If in-laws are offering secondhand clothes or baby goods, or to whip up some freezer meals, say yes. If a colleague offers to make an introduction, make that connection. Be sure to do what you can for all of them in return when you can.

Take. The. Help.

As we mentioned previously, we didn't have family close by that could help, and we hadn't built up a network of friends for support when we were in our grind stage. We leaned heavily on each other instead. We would try to challenge each other's assumptions (gently). We would think out loud so the other could play devil's advocate. We'd play bodyguard for each other, insisting the other partner go take a hot bath or a walk when the going was especially rough. We tried to complement rather than compete. This worked, but only to a point. It was fine if one person was at the end of his/her tether and the other was doing okay. Not so much if we were both frazzled at the same time.

We also coped by finding something we could do together that didn't involve either work or kids. You can do that, too. It might mean a quick game of bowling on a Sunday after-noon or be as simple as watching a favourite TV show together. Snuggle together while you read your favourite books. Walk in a park while holding hands. Sneak in a

collaborative console game. Any form of escape from work and parenting, plus bonding, will be good for your relationship.

THE KIDS ARE ALRIGHT ... ER, AREN'T THEY?

It can be altogether too easy to think of kids as ... just kids, and not "smaller people." They'll be feeling your stress and tension, too, plus their own—and worse, they won't know what to do about it.

If it seems like they act out and press all your buttons when you can least cope with it, that's why.

Our strategy for the kids was to treat them like adults as much as we could. We talked to them about our days in age-appropriate ways. Sometimes, even just saying, "Look, Mom and Dad had a terrible day at work. Could you maybe not pester for dessert quite so much tonight?" would be effective.

We'd explain why things had to be done in a certain way: Less "Because I said so" and more "No, you can't stay up another two hours to watch a movie, because we all get grumpy when we don't have enough sleep and then we all have a bad day." Kids, too, benefit from knowing the bigger picture and the why! It doesn't always put an immediate halt to the toddler or teenager tantrum, but eventually they come around.

Did we always have the patience to explain or cajole? Bahaha. No. But it made a lot of days easier than they

would otherwise have been.

And again, communication should go two ways. We ask them about their days (sometimes you have to ask in a variety of ways to get an answer!), we talk about their favourite shows or books, we listen when they talk about current projects, obsessions, and toys. We also—and this is key—listened to them talk about their stressors and took them seriously.

It's never too early to consciously teach your children coping strategies and self-care. This is especially true for smart kids who might be intellectually capable beyond their years but still emotionally their chronological age (or younger!) Your kids also have access to more and more media and have more time to wallow in it; they need to be taught how to filter and disconnect. Kids can be resilient, but only if you teach them how.

THE DATA

The Grind isn't all bad. The Grind will give you what you need the most to move your business to the next level: data.

You see, once you start regularly filling orders, getting clients, running advertisements, you also start collecting data.

This is a precious resource, so don't waste it.

Keep records of everything. In advertising, track what you spent, where, and what the results were. Campaigns that

work and campaigns that fail.

How big are your manufacturing facilities? What's your throughput? How much input material are you wasting? How much are you using?

If you retail, what's your square footage? How many customers are buyers, how many people just browse? What flies off the shelves? What never moves? At what time of year? Are you tracking inventory closely enough to notice if stuff goes missing or doesn't show up when ordered?

If you run a food services business, how much food spoilage is there? How many times do you have to tell customers, "Sorry, we're out of that today"? How many dishes get broken? Are you constantly having to buy more cutlery?

If you have an online business, install an analytics package. How many people visit your site? Where are they visiting from? How many buy vs. just visit?

You get the idea. Keeping records and having a good filing system isn't anyone's idea of a fun time, but if you invest in doing this right now, it will pay you back many times over later. We'll see how in the next section.

OTHER GRIND STAGE HACKS

One way to weather the Grind stage is to think in terms of iterations. When we're busy slogging it out, we tend to

wish for big splashy fixes. The silver bullet, that one big account, the breakthrough.

It might be more useful to improve using an iterative approach. Rather than trying to save up all your resources for one big push or lay everything on the line to catch that super-big client, are there successive minor improvements you could make to get things running better?

If you run a web-based business, you can do things like streamline your payment process to make it easier for customers to spend with you. If you're in manufacturing, it might be eliminating a single bottleneck in your production process. A food service business might train staff to highlight a more profitable dish more often. And if you sell a product, you don't necessarily have to completely overhaul your offering, but you might tweak one aspect of it once you've determined what benefits both you and the consumer.

A certain social media giant once touted the line "move fast and break things." That only works if you have billions of dollars with which to apologize and fix them afterward, and it doesn't make for a particularly pleasant experience for staff and customers in the meantime.

Specialization

It's tempting, when you're grinding, to consider branching out into seemingly related services or product lines. You might be thinking: well, this new thing I'm thinking about uses similar resources, we kind of understand the market,

and the potential money might be attractive. Or it might even be completely unrelated to what you're doing right now; it just seems like it could be the Next Big Thing.

We did this a few times, both with related services and unrelated products. It really never panned out. One instance was a complete failure; other forays just never really moved the revenue needle for us.

Our problem, we realized much later, was that the driving force behind those decisions was, honestly, "hey, this could be lucrative" rather than "this is a good fit, and aligns well with what we already do."

There's nothing inherently wrong with diversifying or even pivoting your business, but it does need to be well thought out. It also needs to be weighed in terms of opportunity cost. As in, "If we were to put this much time, effort, and cash investment into improving what we're already doing, would we be better off?"

Repackaging

On the other hand, if you deal in information products or services, it might be possible to repackage what you do to create different versions of your product or service to extend your reach.

For example, if you teach online classes, can you create a version of what you offer to sell as an ebook? Or flip that on its head: if you have an ebook, can you do video lectures for people who hate reading and like video learning?

This is particularly attractive if you're a solopreneur. We all remember the pandemic pinch, when we couldn't do a lot of in-person consulting or hit the speaking circuit. Protect your revenue stream against future crunches by considering different formats of the same thing.

Cash Infusions

Now that you have something of a track record, and before you get too big to qualify, start looking for opportunities for free money. That is, look around for grants, contests, and rebates specifically aimed at startups and small businesses. We've included a cash infusions brainstorming cheatsheet in the workbook.

We missed our window for this, and we ended up spending a lot of time in that grey zone, where you're too big to be classed as a beginning business but not big enough that the banks want to throw money at you. (Yes, it's true: banks are far, far more willing to lend you money once you've reached the point where you no longer *need* it.)

Exit Strategy

What, already? We only just survived the Startup phase! But yes, now is the time to consider what your endgame might look like.

Is this likely to be a business to pass on to your kids? Can you structure your company to provide stock options to your children or even jobs when they're older? How are

your taxes structured when it comes to dependants and your business expenses?

Even if you don't have all the answers yet (it might be hard to predict whether junior will be interested in your business if she's still teething), having some ideas in mind will help your decision-making along the way. If you do plan on passing the business along, for example, you're likely to have a longer-term mindset and be less likely to "bet the farm" on short-term gains. Thinking about the future of the business will help you think your way out of your Grind stage.

1. Stats on business failures vary from country to country, and industry to industry. But suffice it to say, the first year is brutal for everyone.
2. This may or may not be an Oprah quote.
3. Lawns are huge time and money sinks and ecological dead zones from a pollinator perspective. Plus gas lawnmowers are loud and smelly. You might want to convert your lawn to native flowers, plants, trees, and shrubs, too.
4. Although yes, in all honesty, that's something to consider, too. Your stress level won't be helped by feeling like you're a martyr, slogging away while everyone else watches the football game or plays video games.
5. As always, be careful to be clear in any such arrangements. You don't want relationships going sour if one party feels the other isn't holding their side of the bargain.
6. And we do mean profit, here. Never, ever bet the rent money, even in "safe" investments, because there's really no such thing.
7. Terry still longs for the days when it was just him and Chandra on the grocery tab, and the bill was around $50.
8. Chandra's personal philosophy is that meetings shouldn't go longer than an hour, *ever*.

Wow. You've survived Startup and The Grind. Champagne! Dancing! And welcome to The Plateau.

The Plateau is that stage where you've ironed out the worst of the bugs in your business, you're mostly profitable, your company culture is decent, and staff turnover is as low as you can get it. You're a bit more relaxed. You have some money in your pocket.

At home, most or all of your kids are out of diapers, are able to dress themselves, do up their own seat belts, get their own drinks of water, and even pitch in around the house. They're probably all in school for most of the day. If you have special-needs kids or additional family concerns, you might be able to afford to get extra help by now.

Depending on your personality and mindset, The Plateau is either:

1. A generally happy place where you can consider yourself successful. Flick on the cruise control, baby, sit back and enjoy the ride, *or*

2. A frustrating period where you've survived the first few years but you don't feel like you're *thriving*. You worry about stagnation or being outcompeted. Growth seems impossibly slow, maybe even flat. You haven't broken that milestone revenue number yet. You feel like you just need to get that one big break or one big client. House chaos is only down to a dull roar, and if you have to look at that crack in the ceiling one more time ...

Neither of these perceptions of this phase is right or wrong. And you might feel like it's both of these things. You might start off in this phase feeling like cruising is a great idea, and then after a while, you get antsy. Or you might start off feeling frustrated, but then decide, you know what? Here is a nice place to be, after all. It might even be a mix of both, depending on the day.

One way or the other, you'll be dealing with the same sorts of issues as in Startup and The Grind, but they'll have a new flavour. Let's have a look.

WHAT IF ...?

With more room to breathe, you have more time to think. That can be a mixed blessing because you can get mired in reviewing the past.

For us, our what-ifs were:

- What if we hadn't taken that left turn into translation services and lost tens of thousands of dollars (!) when we could ill-afford it?
- What if we hadn't decided to homeschool our kids (which took up hours of our day and made things a lot more difficult on a lot of fronts)?
- What if we had made smarter hires in IT earlier on?
- What if we had taken *that* trip with the kids?
- What if we'd made time to do that science kit project when it arrived, instead of letting it sit there for years? Did we miss a critical bonding opportunity?
- What if we didn't have to spend so much time dealing with difficult relatives?

And on and on it goes. You can spend an awful lot of time feeling guilty about what you think you should have done and when. But spending a lot of time on where you *could have been, if only* ... is a recipe for resentment and bitterness. It's also futile because you can't, as they say, change the past.

Absolutely, take stock of where you are. But do so with the intent of celebrating what you have done, not beating yourself up over what you missed or screwed up. Even if you feel there were lots of missed opportunities and far too many screw-ups. Learn from your mistakes and set them aside.

Because here's the thing: Thanks to the power of hindsight, we can tell you that those things that we agonized over in the Plateau phase turned out to be either inconsequential or even beneficial in the long term.

We survived the loss of money on our translation services gambit and realized that our focus should be on our core strengths as an organization. We doubled down on what was working instead of allowing ourselves to be distracted. Revenues and profits went up after that.

Our experience with homeschooling ended up making the pandemic lockdown easier to bear. We knew how to teach the kids at home and still had some resources from before. (In fact, it was almost easier than pure homeschooling because we had teachers interacting with the kids remotely, rather than absolutely everything depending on us.) The kids weathered it better too.

We learned how to spot really good IT hires and got some that helped the company grow like crazy.

We took other trips with the kids that were better than what we'd originally planned, and because the kids were older, they remember more of them.

That one science kit is still sitting around, even as we write this;[1] it will eventually be rehomed at a school where it can be used. But we've done tons of other things in the meantime. We learned the value is in the time spent together, not the project itself.

AM I DOING IT WRONG?

All the doubt on The Plateau comes from one source: measuring yourself against others.

We see the business press, which covers *multimillion-dollar* buyouts of some random business that has a dubious model and has been in operation for all of six months and think: huh? And probably also: Where's MY personal jet? It's really hard not to be jealous.

Which is why it's important to realize that very few of those flashy deals have anything to do with the quality or worth of the business being purchased.

Sometimes, they're the result of hype. Big-time investors can be bamboozled as easily as small-timers can; fear of missing out on a potential blockbuster can make a lot of people throw money at something that doesn't deserve it. Check out the history of the 1990s dot com boom and bust if you don't believe us.

In other cases, investors are spreading their bets. A lot of venture capitalists, for example, will take stakes in hundreds of companies in the hope that one of them will be a "unicorn" and give them a big payout.

In still other cases, a buyout or investment might be for tax purposes, for poaching staff and intellectual property, or for gaining a business presence in a country/market of interest. And of course, we'd be naive to forget about the possibility that a small percentage of deals are for nefarious purposes, like money laundering.

In other words, don't take it personally. Business isn't as much of a meritocracy as you might wish it to be, so don't let yourself get too green with envy.

The other thing to remember is that business deals don't just "happen." In general,[2] you don't suddenly get a phone call from Mr. Moneybags saying, "Hey, great business you have there. Can I buy it?" Deals happen because you've marketed your business well, made a name for yourself or the business in your industry, and done a lot of public relations work ahead of time. Networking with the right people is also a factor, and your physical location can be too.

Oh and by the way, here's another insider tidbit: business awards don't just "happen" either. Businesses win them by actively seeking them out, (usually) ponying up an entry fee and putting together a stellar application package.[3] Indeed, let's talk about how to use these and other methods to get your business off The Plateau.

AM I DOING IT RIGHT?

If you were paying attention in the last section (and you were, right?), you'll have a treasure trove of data collected by this stage. Now is the time to mine it, if you haven't already. Here are the questions you need to ask your data (these are also covered in the workbook, in a handy Q&A format):

Customers

1. Who are your best customers? Your definition of this might vary, but it usually means most profitable. It might also mean the ones who bought your product or service with the least amount of handholding or selling, or customers who gave your staff the least amount of grief.
2. Who are your repeat customers? Who comes back to you time and time again?
3. What can you observe about your best and repeat customers? Are they all aged eighteen to thirty-five? Are they men? Women? Non-binary? Affluent or struggling? What area do they live in?
4. How did you acquire your best customers? What advertising or marketing brought them in?
5. Where might you find *more* of your best customers?
6. What does your sales cycle look like? How long does it take a customer to go from browsing to buying?

7. Who are your worst customers? You know, the ones who constantly complain, demand refunds, or want a great deal more than they're actually paying for?

8. How might you avoid attracting more bad customers?

Having looked at the data and teased out some answers, you can start using your superpower: decision-making!

What decisions could you make? You could decide to increase your advertising budget and focus it on the stream that is currently bringing in your most profitable customers. You could find cheaper or more efficient ways to spend your advertising dollars by more directly targeting your ideal customer, now that you know what sort of person that is. You could find ways to shorten your sales cycle.

One of our best decisions in this area? *Firing* a customer!

You read that correctly. Every industry has bad customers, the ones that give you oodles of work but also have endless complaints. You would think that, if you didn't like the way a company was serving you, that you'd discontinue using the company, right? Not so. No order is ever up to their standard, yet they keep coming back.

We told our bad customer that we wouldn't be taking any more of their orders. This was a tough decision because on paper, they were bringing in a decent chunk of revenue. But they were also making our lives absolutely miserable

and getting in the way of us serving our other customers. Obviously, you shouldn't fire a customer if they rightly call you out for bad service or product; your first action should be to rectify the complaint, your second action to fix your processes so that it doesn't happen again. But if you have a chronic complainer ... you need to judge whether they're worth it.[4]

Product and Services

There are a number of questions you want to ask of your product and service data, including:

1. What is your best seller? Remember, there are a lot of ways to look at this concept. Best seller could mean the number of sales. It could also mean revenue or profit or ease of production.
2. What is your worst seller? Flip the above question on its head. What is the least profitable? Why? What doesn't sell well at all? Why? Is it a question of no demand, or is the product or service just not up to snuff?
3. What costs are you externalizing, and are you completely comfortable in doing so? What do we mean by this? Consider beverages sold in plastic bottles. The company selling them gets to cut their shipping costs by using lightweight packaging but externalizes the cost of recycling them to the taxpayer or the environment.
4. Is there room to do an upsell somewhere in your sales process? What about a "value-add"?

In this area, you could decide to streamline your product or service offerings (not a bad plan, as customers can be overwhelmed when faced with too many options). You might decide that something isn't selling because it isn't being marketed in the right way; instead of dropping it, you might shake up your marketing mix for that product or service. You might realize that some of your products or services are externalizing costs but that there's a way to make that product cycle more circular and, in so doing, cut even more costs.

In our case, when we examined customer service trends, we realized that a lot of customers were asking if we offered a turnaround time that was faster than twenty-four hours. We dug deeper into our metrics to determine if we had the capacity and began offering a twelve-hour return ... at a premium price. Lo and behold, a lot of customers changed from our twenty-four-hour return to use the premium service, and we were getting a lot more revenue. We also attracted a lot of new customers who had apparently been looking for a company that provided faster service. A win for everyone.

Staff

Your employees are critical. The secret to any high-functioning company is having the right people in the right roles and a company culture that treats them well. Here's how you can figure out how to make that happen:

1. Who are your best staff? This one is tricky.

Depending on how big you are, your definition of "best" might vary depending on role, but one way or the other, be very, *very* careful as to how you define best here. Is your "best" customer service person the one who churns through the most customer service inquiries in an hour, or is he the one who actually resolves issues to a customer's satisfaction? Is your best salesperson the one who sells the most product? Or is she creating huge problems for your other staff by promising too much?

2. Who are your worst staff? Again, take the time to look at the big picture. You can have an employee who comes in early, works late, is brilliant with customers, but is so rotten to the rest of the staff that your company morale is in the toilet. (Think: brilliant jerk syndrome). You might have one that spends a lot of time attending to *you* but is awful to your customers when you're not around.

Here, once you've decided who your best employees are, you'll want to ponder what makes them that way. Is it company culture fit? Personality? Training? Then you'll need to decide how to get more of those employees, or better yet, how to encourage existing employees to become better. Work with your staff to set personal and company goals they can attain, talk to them about what they want out of their career path during their time with you, lead by example, make sure your training is up to date and easily

accessible, and don't expect them to do their training while off the clock.

For those employees that don't seem up to snuff, first determine if it's the job or the person. Is the role properly defined? Are the requirements or deliverables clear? Are they just in the wrong position? Would they do better in another role at your company? Do they have the resources they need to get the job done?

If it is the employee, and the issue is something that could be fixed, like on-the-job performance (and not interpersonal, like harassment or other forms of violence), do offer them the chance to do better. Put together a performance improvement plan in writing. Make sure you document the times when things go right as well as when things go wrong. Give them the opportunity to turn it around!

This is not only just the same sort of thing you'd hope for if you were in their shoes, but it makes good business sense. After all, you've already invested time and money in training this person, and it's going to cost you to replace them. This should really go without saying, but we'll say it anyway: be fair to both that employee and the employees that have to interact with that person.

With all of these considerations exhausted, it will sometimes turn out that an employee isn't the right fit for your organization for a variety of reasons. Sometimes you do have to fire people. It's our least favourite part of being in business because it's deeply unpleasant.

If it does come to that, be sure you're familiar with your local labour laws and do it by the book. *Don't skimp on this.* Consult an HR firm to help you do it correctly. Pay up on holiday or back pay owed and whatever severance they might be allowed. Not only is that the right thing to do, but it protects you against lawsuits and mitigates the risk of an employee doing things to harm your business after the fact.

If you don't yet have in-house HR management and have to do this yourself, have someone else in the room with you when you do conduct a termination to act as a witness. Remember to collect keys or access cards from the employee you're letting go, help the employee collect their belongings, and make sure you—or if your business is big enough, a security officer or your HR manager—walk them out of the building.

Most employee terminations go as expected—the employee probably knows it's coming—but if the employee has been especially problematic, there's always the chance that they will do something rash in the heat of the moment.

If you have to terminate an employee, keep your communication about the termination to the rest of the staff brief and professional. Definitely keep your opinions about the situation to yourself. The way you handle this will set the tone for the rest of the staff.

Make sure you have a post-termination tidy-up process too. Immediately update passwords as necessary, make sure access to social media or other digital systems is shut off, send out the required paperwork to whatever government

agencies need to know, and make sure the email address they had is forwarded to the person you've designated to cover their role in the interim.

Processes

As you will have gathered by now, we're pretty big on processes and checklists. They sound boring, but really, that's what you want for most aspects of your business! When your business runs smoothly, everyone is happier, and you can devote more time to improvements and new ideas. Seriously, who wants to spend all of their days putting out fires (unless you're a firefighter!)? Here're some ideas for questions about your processes:

1. Do you know where your advertising money goes? Do you know how much of it is *effective*? What's your return on ad spend (ROAS)? What's your customer acquisition cost? How much does a customer buy from you, once acquired?
2. How about your marketing efforts? How well is your brand known in your industry and outside of it? Have you started making news in your sector? Have you won any awards that might make you look attractive to customers? To potential investors, partners, or buyers?
3. What production runs or services are running smoothly? Where are you constantly having to patch things up?
4. By now, you've probably attended a few conferences, seminars, webinars, etc. Did you

learn anything at any of these events? Did you *act* on anything you learned? If not, why not?

If you haven't had a continuous improvement mindset in place about your business before now, it's time to create one. Remember the project board where we dumped all our ideas for improvements and changes? That's a good starting point. But now, you should make a regular habit of reviewing all of your processes at least once a year to make sure they're working as intended. You should also be encouraging your staff to find ways to make things better for customers, for their colleagues, and for the company as a whole. No process is written in stone; you should be able to update or improve it as the need arises.

Don't panic! You don't have to review or fix all of your processes all at once. Do one department or section per month. It's more manageable that way. Take notes, and refer to the notes that you made the last time around: Did the changes you made during your last audit improve things? Make things worse? Why or why not?

Especially take stock of what you're doing to keep both you and your staff current in terms of training and your industry trends. Do you have the certifications you need? Are you complying with regulations? Is there some new development in the pipeline that represents either a threat or an opportunity? It's super easy to get so caught up in the day-to-day minutiae of running a business that you forget to take the thirty-five-thousand-foot view now and then. History is littered with dead companies that

failed to adjust or adapt. Make sure you aren't one of them!

On the other hand, don't get done in by "analysis paralysis" or get so consumed by "learning" that you forget about the "doing." You can go to ten conferences a year, but if you don't do anything with what you learned or make a solid, genuine connection with the people you meet, it's time and money down the drain.

Last but not least, your number-one process should be what we call "change communication." That is, when a process is changed, there should be a "change comm" to everyone involved so that they're aware it has changed. We used our task management software to assign a "review this" task to involved parties so that we were sure they'd seen it too.

Competitors

Here's another thing you should have a process for: analyzing your competitors. If you work in a fairly straightforward, slow-ish industry, a yearly audit should be fine. If you are in a fast-paced sector, this should be done at least quarterly. Here are several starting points:

1. Who is your biggest competitor? What do they do or offer that is different from you?
2. What's their competitive advantage? Can you match it or beat it? Can you compete on different terms? (E.g., if you can't beat their price, can you offer a premium version of what they do?)

3. Look at where they advertise, examine their marketing efforts, and check out their press releases. What have they done that you haven't but could?

4. If you're in a technical, scientific, or medical sector, are you watching for new academic papers in your field? Do you need to be aware of patent filings? In your home country and abroad?

5. Read your competitors' reviews. What problems do they seem to be having? Why are customers praising them? How can you be better? How can you avoid the issues they're experiencing?

This can be gut-wrenchingly scary! It's tempting not to look at your competitors at all, because what if they're dancing rings around you? What if they're so far ahead that you feel you'll never catch up? So much easier to plug our ears and close our eyes and sing la-la-la ...

But ... better to know what you're up against and where you stand. Especially since they'll almost certainly be watching what *you're* doing! And in all likelihood, you'll find places doing better than you are and places doing a lot worse. You can enjoy a moment of schadenfreude if you see a competitor making some of the same mistakes you made a while back, and you can whistle in awe of some of the cool things the Big Biz is doing. Then you can knuckle down and see what it makes sense for you to do.

That last sentence is crucial. Just because someone else is doing something, that *doesn't mean it's working*. We saw a

lot of competitors come and go during our time at the helm of our editing company. One, for example, seemed to have an endless banner advertising budget right out of the gate; we'd see them everywhere for months (even before ads could "follow" you around the internet). But clearly, that was the only thing they put their money into, because one day they were gone. Their domain name no longer resolved to a website, just one of those annoying search results pages.

Others stayed around and even grew bigger, though they never surpassed us. Still other companies limped along, never quite dying, but never doing much of anything. And of course, there were a few venture-backed companies that entered the market in a huge way and stayed there.

Learn from all of them. Check in regularly, and compare notes on what's changed and what's stayed the same. Learn and adapt as necessary. Respect the law: Don't swipe proprietary stuff, be careful of intellectual property rights, and make sure that you're doing something because it makes sense and fits your business plan, not because you're keeping up with the Jones or because it looks cool.

CHECK-IN TIME

Have you been taking off your hats?

Previously, we advised you to hire staff as soon as you thought you could afford it (and possibly even a little before that). Business owners tend to wear too many hats

and forget that they don't have to do everything themselves.

If you haven't, or if it's been a while since you've done a reality check on this issue, do it now. Start stress testing your business. Find out how well it gets along without you. If you can't go away for a day without someone calling or texting you about an issue that can only be handled by you, you're doing it wrong.

Remember:

1. Your processes should be documented. No one should have to be asking you how to do routine stuff.
2. Your staff should be empowered to make decisions and should be happy enough in their workplace that they'll make those decisions wisely. Good leaders make more leaders.
3. If you're still, at this stage, working sixty-plus hours a week, there are more hats to take off.

Once again, have a good hard look at everything you're doing in that week, and ask yourself whether any of it can be automated, given to a virtual or personal assistant, hired out to a contractor, or made into a viable part-time or full-time role in the company.

Because here's a secret we've been hinting at in previous sections on this subject: real wealth isn't money. It's *time*.

Time is the one thing we can't manufacture. We can usually find ways to make more money, but we can never make more time.

We can, however, exchange cash for things that will help us make better use of our time. And that's the true value of money.

Indeed, thinking of money in terms of its relationship to your time is a good way to get off the consumption tread-mill (you'll recall we talked about being envious of the Joneses in the early chapters and the damage that does), and it might help you make better decisions about your money and your business. For example, a flashy sports car might be attractive, and maybe being able to afford one is a goal of yours. But consider whether it gives you more time. Chances are, it will require more frequent trips to the gas station, it might need expensive and hard-to-source parts for repair, and depending on how you drive, it might create problems when the police pull you over. Again.

On the other hand, being able to upgrade to business class whenever you feel like it (or first class or whatever it's called) is something that may save you time. It usually means access to a lounge where you can work or relax, easy access to food and drink, and little-to-no standing in line for things. It can mean arriving at your destination feeling much better rested and capable. This might not be something you do for every trip, but it's an expenditure worth considering for important trips where you want to bring your A-game.

Trading money for time in your business will also allow you to focus on the things that matter (family, friends) and give your brain the bandwidth it needs to make better decisions about both aspects of your life.

What's a good goal here? You should be able to be away—really away—from your business for a whole month (yes!) without things falling to pieces.

FEELING BETTER AND BETTER

Beyond a certain point, it's hard to trade money for more time at home. We've already covered how to look for things that can be outsourced or automated and generally made easier at home in a previous section. So, how can we make the best use of our income?

We've suggested ways to keep your health at least on an even keel during the high-stress Startup and Grind phases, and hopefully you've done that and perhaps even made some progress beyond that. But now we want to use whatever disposable income we have to really double down on wellness. And no, we don't mean investing in those miracle cures and devices they keep touting on late-night infomercials. Things like...

Food

How long has it been since you really examined your grocery cart (or your takeout bills?) An excellent use of your money would be to upgrade your diet. This might include more nutritious cuts of meat, if you eat it, more

fruits and vegetables (which are, sadly, way more expensive than junk food), better quality versions of everything, more whole grains, and less processed stuff in general. Trade in that sugar for herbs and spices.

Sleep

There's a computer game called *The Sims*®, where you guide a character (or characters) of your own making through life—romance, jobs, travel, the works. One of the first things you do to improve a Sim's life when you can afford it is upgrade their bed. As in art, so in life: invest in a good mattress and pillow.

We know, we know. Seriously? You're talking about mattresses now?! But so, so important. And you've probably been scraping by with whatever you could afford or whatever you got from someone else all this time.[5] Mattresses are very pricey! But they're important for a good night's sleep, and a decent one eliminates an astonishing number of aches and pains. It's such an easy thing to overlook. (Be sure to dispose of the old mattress properly.)

If you share a bed with a partner and are constantly pulling the top cover off each other, consider buying your bed set parts separately ... and get an oversized cover (duvet, quilt, bedspread, whatever the word is in your area). Our nightly tug of war mostly ended when we got a king-sized duvet for our queen-sized bed.

Temperature is another important factor. Generally, cooler is better. Turn down the heat in the winter, and maybe install a ceiling fan for the summer months.

Darker is also better. Invest in light-blocking drapes, keep the electronics out of the bedroom, or at the very least shut off anything that glows (except your alarm, of course).

Footwear

More obvious-but-not-obvious advice: Invest in better footwear! So much of what we put on our feet is status or fashion related, but rarely do we consider what the shoe is doing to our backs and legs, and for women's high heels particularly, our toes. Do we expect you to buy boring, "sensible" things you'd expect to see on someone ninety years old? Of course not. But do invest in good quality, proper fit, and swap your insoles for custom orthotic inserts where possible.

Working Out

Did you used to have a favourite sport or some other athletic activity that you've let slide in these busy years? Is there something else you've always wanted to try? You should start easing into it now. If you used to run, don't sign up for the next ultramarathon, but do lace up the shoes and go around the block a few times a week. Get a gym membership or buy the equipment you're *likely* to use at home. For example, neither of us is into running, but we can work up the minimum amount of enthusiasm required to row, so a rowing machine was a better buy for us than a

treadmill. Chandra finds that she's more motivated to row when she only allows herself to watch a TV series she's hooked on while rowing (she streams it on a tablet.)

If you're more motivated by classes, now's the time to fork over for one, either online or at your local fitness centre. Or join a home league for your favourite team sport. Why should the kids be the only ones to enjoy soccer (football) in the summer?

Holidays

Repeat after us: it's time for a proper holiday.

Not just an afternoon of escape or an evening of zoned-out binge-watching on the couch. An actual away-from-the-business holiday. Turn off your emails, tell your staff to contact you for emergencies only. Take the laptop only if you must, and leave it in the luggage unless you absolutely, positively must use it.

If the very thought of being away is giving you the heebie-jeebies, go back and look at every section on time management again. You should be working *on* your business, not *in* your business. Disentangle yourself, stat.

Start with a full twenty-four hours away if you can't manage anything else yet, and work your way up to a couple of weeks. Properly disconnected breaks will do you, your family, and your business a world of good.

BIGGER BUSINESS, BIGGER PROBLEMS?

By and large, you should be feeling somewhat less stress on The Plateau. Sure, you might be anxious as to why you've plateaued, but you shouldn't be feeling like every day is a struggle for survival anymore. Dare we say, it might even feel comfy here?

That's not to say things will be stress free. They never are. Your business stress now will come from a few new sources. Let's look at some.

Work Dynamics

Where once you were a small shop with only you and your partner or a few new hires, you may have brought on a bunch of new people. That's a whole bunch of new relationships, and not all of them will be roses and unicorns.[6]

Obviously, you don't have to have everyone get along with everyone else, but you do have to make sure that you (or if you're big enough, your HR manager) are working to minimize office dramas and politics. And you have to make sure everyone is getting clear messaging about their jobs, company policies, and the company's goals. Everyone needs to know what they're supposed to be doing and why.

One of our issues in our first venture, possibly because we're polite Canadians, is that we didn't use firm leadership language when talking with our staff as often as we should have. For example, if we were having a meeting about how to solve a particular problem, we'd say things

like, "Maybe we should do X ..." or "We should think about Y ..."

That's fine when you're troubleshooting or thinking out loud, but at the end of such a meeting, you'll want to give clearer direction on what you want your staff to do. "I want you to do X, please, and get back to me as to whether that fixed it."

Something else that might be very stressful as your company grows is what to do with longer-term staff who don't want to grow and change as the company does. If their role doesn't change much over time, there might not be a problem, but in some cases, the role might have to be altered to fit new requirements. Or you might find that they actively work against change in areas that aren't really in their remit. Some people just don't cope with change well. In that case, you might have to find a way to ease them into another role or encourage them to move to another organization. Either way, it can be hard to make the whole thing fair to all (the loyal stalwarts and the fresh-faced go-getters) involved, and that can be super stressful for everyone.

Another new set of complications could be a board of advisors or new investors if you decide to go down these routes. Advisors can be very helpful: they can provide their collective wisdom and experience, take an objective look at what you're doing, and in so doing, boost your business to the next level. Investors can do that if they're not the "silent"

version, and of course, they bring much-needed capital for expansion.

However, if you don't get the right mix of advisors or end up with investment terms that become problematic, you've bought yourself a new set of headaches. As always, you'll have to do a cost-benefit analysis on whether what you get out of these business relationships is worth the stress they may (or may not) bring.

A final potential source of stress is "shiny object syndrome."

If you feel like The Plateau is a "stuck" phase, you may find yourself spending a lot of time and energy looking for the magic tactic or major account that will bring about the "breakthrough." You might cycle through a bunch of things, drop a lot of money on conferences, webinars, "systems," and waste a lot of resources on stuff that ultimately doesn't work.

Spoiler: It will probably not be a single major epiphany that moves you from this stage to the next, but rather a combination of all the improvements we've suggested here. If you *do* have an epiphany, it's almost certainly going to come to you when you're not actively thinking about solutions. In other words, it will come to you when you're taking time off work!

On the Home Front

At home, your kids are becoming more independent. That's great! It means you don't have to do everything for

them. They're also becoming *more independent*. That's terrible! It means they don't always do what you want them to do. Sigh.[7] As your kids get older, they do things like testing and pushing boundaries, making more messes than they help you clean up, getting into fights, doing completely unexpected and sometimes totally irrational things,[8] and generally driving you mad.

We use several tactics to cope. Structure helps a lot. Being at loose ends or bored is its own kind of stress. As we noted in a previous section, we were generally very clear on what we expected our kids to do on any given day with respect to homework and chores,[9] and that also helped us be fair and not have arbitrary rules or requests. The kids were allowed video games and/or TV time once the work was done, and during their unstructured time, they were asked to amuse themselves when they were old enough, so they learned how to make choices about what to do with their time, as well.

Working as a group or one-on-one on various projects and jobs was also important. We cooked and baked together, built kits and models together, and watched movies as a group, too. Board games were lots of fun, and so were house renovation projects. Day trips were loads of fun, and we would quite often decide to bin the day's schedule and go for a hike just because the weather was nice.[10]

The biggest help, though, was investing as much time as possible into talking to, and especially *listening* to, our kids during ordinary moments. Chatting while slicing carrots.

Doing a shared journal together. Listening to what happened at school. Colouring a picture with them.

Real wealth is being able to spend time the way you want to.

GETTING UNSTUCK

If you've been through all the previous stages on The Plateau and you still feel stuck, it's time to have a look at that "wouldn't it be great if …" file folder, or whatever it is that you've called the place where you've been dumping your ideas. You should also review your notes from any previous webinars, conferences, or other business books (including this one).

Aaaannd now you have a bunch of potential solutions—but you have no idea where to begin, right?

Let's go over a few techniques for changing our thinking.

Impact

First, you can try what we call an "impact filter."[11] Which of these ideas for improvement is going to have the most positive impact (so, say on revenue, fixing a problem or problems, or profitability), and the least negative impact (things like monetary cost, time to implement, disruption, and upheaval)?

For example, one of the things we considered doing was moving our business from our existing building to one downtown. We needed more space, and while our location

at the time was nice, it was fairly utilitarian. There was a certain appeal to shaking things up a little and giving our company more of a cool-kids vibe.

So we ran it through our impact filter. We totted up all the positives (closer to a variety of restaurants, nicer location, more modern décor in the office, a feeling of being part of the city core) and the negatives (having to change over a heap of things to reflect the new address, moving the computer systems and phone lines, higher per-square-foot rental costs, staff safety at night, fewer parking spots). In the end, we decided against moving; instead, we expanded where we were.

Replace Yourself

If a methodical review of your ideas bin doesn't produce the results you want or just doesn't appeal right now, why not try to imagine what someone else would do in your place?

One of the main reasons we get stuck in ruts or trapped on plateaus is that by this point, we've got a lot of mental baggage with the business. It's the tyranny of history. You can end up doing something in a certain way for so long that you forget it might not be the only or best way to do it.

So, who are your heroes?

They could be business heroes, philanthropy heroes, or even comic book superheroes. It might even be someone closer, like a family member or friend. It doesn't matter who they are, as long as they have some significance to you.

Think about everything you know about them—how they act, react, think, and plan—and then imagine what they might do if they were in your shoes.

Now, if your hero is Captain America, hopefully we don't have to tell you that flinging a large metal shield at the wall is not a great idea (as tempting as that might be on a frustrating day). And it's probably not a good idea to frame conversations with staff around phrases like "It's what Cap would do!" Not unless you want them resigning to work for someone who sounds a bit more stable, anyway. No, the goal here is to break *your* thought patterns and habits long enough to inspire something different.

This can work both on the job and at home. After seeing Terry's mother in action with our kids, Chandra began periodically reminding herself to "parent like Grandmum does." That is, being more patient and trying to remember what it was like to be that age. (Terry's mother was not only an excellent parent to her own kids, she worked as a math teacher and often dealt with troubled children.)

Does It Hafta?

Another technique for breaking habits is to ask a simple question: Does it have to be this way? Quite often, the answer is no, not really.

One thing that we shook up by asking this question was staff work schedules. The standard is "nine to five," and there's nothing fundamentally wrong with the practice for most desk jobs. In our case, though, we found that offering

longer shifts over a four-day period solved some issues for us. It benefited us by allowing in-house staff to complete work on long documents without handoffs, and it benefited staff by giving them a four-days-on/three-days-off setup. The staff who opted to work this kind of schedule effectively got three-day weekends, and it lowered child care costs for some working parents.

Go Negative

One last technique to consider if you're having trouble deciding what to tackle in the Plateau stage: look at the worst-case scenario. That is, ask yourself: If this issue goes on, what's the worst that can happen? Looking at it from this angle might help you prioritize and give you some perspective.

In our case, we ended up going longer than we should have without updating our emergency preparedness plan. We'd gotten too busy because we were expanding, and the old plan didn't account for the new positions we'd added, our newly expanded office space, and extra equipment, among other things. It's also human nature not to want to think too much about potential catastrophes or even inevitabilities,[12] so it's easy to put something like this off. Looking at it from the "go negative" angle, the answer to "what's the worst that can happen?" was: we'd be screwed. Having to figure out how to run your business in an emergency when you're actually in the middle of an emergency is a good way to lose your business!

On the other hand, one niggling issue that bothered Terry a lot was the fact that our website FAQ section was borderline ugly and not as functional as it could have been. He'd frequently bring it up at our weekly board[13] meetings as something that he wanted to fix but hadn't been able to spare the time. Eventually, at one of these meetings, we looked at our website data to find out how many visitors actually looked at our FAQ page. The answer? Practically no one! This in spite of it being prominently located in the top menu bar, and linked from every service and product page, as well. Terry was able to stop feeling guilty about not getting to it. (Although, strangely, he was able to feel smug when he did eventually get it sorted!)

———————————

1. Sigh.
2. Insert your own standard disclaimer about there being exceptions to every totally unscientific generalization we make here.
3. Believe it or not, there's a whole sub-industry devoted to polishing these packages.
4. Especially true of products or services where there's a lot of subjectivity involved, like graphic design.
5. This was us. A very cheap mattress that was approaching fifteen years old when we finally clued in. We like being thrifty, but that bed had nothing left to give at that point. We felt *so* much better, once we'd replaced it.
6. Interesting exercise: on a scrap piece of paper, scatter dots around the page, one for each person in your organization. Now connect each dot to every other dot. You've just made a visualization of all the relationships in your company. It's kind of astonishing how quickly that gets messy when you add new dots!
7. One of our employees once helpfully worked out precisely how many years of "teenager" we were going to have to endure because we had four kids. There are some numbers you really don't want to know in advance.

8. So much of parenthood seems to involve saying things that you never expected to have to verbalize. Like, "No, you may not use the glass pot lids as pretend Spartan shields." Or "No, your ceiling fan should not be used to fling things at brothers coming through your bedroom doorway."

9. That clipboard idea you probably snickered at in that section? Being able to keep track of whose turn it is to take out the recycling saves so many "But I did it last time, I swear!" fights between siblings. Worth its weight in gold for that alone. GOLD.

10. Where we live in Canada, the temperature ranges between -40 oC and +40 oC. So any day when you're not actively freezing or melting counts as nice, eh?

11. This is also a kind of cost-benefit analysis, but calling it that makes it seem pretty darn dry and boring, and something only the accountant would do. "Impact" is more action oriented, and that's what you, as the entrepreneur, need to be. Cost-benefit analysis is also focused on finances, whereas impact considers that *and* things like time, people, company ethos, and so on.

12. Speaking of which: for the love of whatever deity you hold dear, please set up a will. Like, right now. When Chandra's father passed away without one, it took more than a *year* of wrangling with the banks, his company pension fund, the government, and the lawyer to get a very simple estate settled. Even if all you can manage to spare time for is a simple fill-in-the-blank will kit purchased at the store or online, that's better than nothing, and it will make things so much easier for your loved ones and employees.

13. In our case, the "board" was a cheese board and the meeting was between the two of us over a glass of wine. Hey, if you're going to have to spend your Sunday evenings preparing for the work week (once you've finally managed to get the kids in bed!), you might as well do it in style, right?

Wow. Having figured out what worked and doubled down, you're finally breaking through! This should be a period of growth—maybe steady, maybe even hockey-stick shaped. On the business side of things, this is a great place to be. At home, your kids might now be teenagers or perhaps taking their first tentative steps towards adulthood. You might also be in a position to be caring for parents and in-laws. Let's have a look at what we're facing and how we can handle it.

MOVING UP?

Good news! At work, the worst of your guilt has likely abated by now. Regrets, you'll have a few, of course, but you'll have seen enough of the business roller coaster to be a lot more philosophical about it all. You'll start referring, as we did, to those long weeks and months of slogging as "the bad old days," and you'll have a finer appreciation of things like a quiet meal with your family, weeknights and weekends off, and the occasional sunny afternoon spent beside a pool.

This is a really good time to count your blessings, and you might even consider what you can do to "pay it forward."

Do you have time for volunteering? Is there something you can do in your industry to make it better? What about in your community? What can you do to make your neighbourhood or city a cleaner and more welcoming place? Are there any global issues that you might now be able to apply your hard-won wisdom (and/or money) to?

If nothing comes to mind right away, that's okay. But do set aside some time to brainstorm some ideas for what you might do. We'll come back to why it's important to start thinking about this a little later on.

At home, what you feel now will depend an awful lot on how you got here. If you prioritized your family from the beginning, as we have suggested, you'll have invested in your children as much as you did your business all this

time. With any luck, your family appreciates what you've managed to do for them and will admire the example you set, as well. Perhaps one or more of your children has expressed an interest in (or is actively working in) your business at this stage. We'll come back to that soon, too.

On the other hand, you may have reached this growth stage of your business by relentlessly and exclusively focusing on it and are now realizing that came at a personal cost. You and your life partner might be having major issues; perhaps you've lost touch with friends and some of your family members. Worse still, you might have lost your connection with your kids, or they might be in trouble in some way.

If that's the case, your approach from here on in isn't that much different from someone recovering from substance abuse; indeed, you've essentially been a workaholic all this time, and the damage that can cause is similar.

First, start by owning up to your mistakes and apologizing for them. Then do your level best to make things better, if you can.

Prioritize your kids and your partner. Do start by being there for them and offering them help with whatever they're currently going through. Don't expect them to do the emotional work of telling you what needs to be fixed or how you can do better. Be each other's sounding board, and don't assume that everything is going well (or badly) because no one has explicitly told you otherwise.

Definitely go for counselling and other forms of outside help if the situation warrants it. We realize that can be hard, especially for us entrepreneurial types, as we like to think of ourselves as independent souls with the ability to solve any problem we're presented with. But this is *not* the time to try to muddle through or wing it. Get expert help, and don't expect anything to be resolved quickly.

JUST A SHADOW OF DOUBT, NOW

While you have less cause to doubt your business acumen overall—you made it this far, right?—you might be feeling worried about some other things at this stage.

There's always the economy to worry about. If you've been running your business in a period of economic good times, there might be a slowdown coming your way. During our time at Scribendi, we survived the "dot com bust" and the 2008 global financial crisis. We later managed to start not one but two new ventures just as the 2020 pandemic hit. One thing is for sure: whatever the current situation is, it likely won't be the same in a year or two.

The other form of doubt at this stage will be more personal. In spite of everything you've been through, we bet you still occasionally ask yourself, "What if this wasn't talent? Maybe I just got lucky." This sort of thing is sometimes called "imposter syndrome," and it's probably why so many entrepreneurs go on to start new businesses[1] after they're done with their first one.

You might also question whether you deserve what you have. This is actually a good and healthy doubt to have! If you don't believe us, then take a moment to think about some of the people you met who went to great lengths to tell you how they deserve everything they have and how, in fact, the universe actually owes them a great deal more. Chances are they weren't the sort to deal fairly with life and business partners, their kids, their employees, or their customers. The fact that you worry a little means you're still as humble as you need to be, and you'll continue to look for ways to be better. But do take stock of what you've accomplished, and give yourself the odd pat on the back!

THE MOST DANGEROUS TIME

With everything in your business firing on all four cylinders, so to speak, and hopefully things mostly on an even keel[2] at home, you might find yourself getting restless. Where once you thought you'd never have enough time in the day, now you're not sure what to do with all your time![3]

If we don't recognize this feeling, it can cause major problems. We might start yearning for a bit more excitement, so we make some risky investments. Or we expand the business into something that doesn't make any sense. At home, the dreaded midlife crisis might have us shopping for a trophy husband and a little red sports car. In other words, we go looking for trouble.

Don't do this.

You really don't want to have shed blood, sweat, and tears for all this time only to have it all crash and burn because you got a case of the fidgets. We've seen it happen so many times in our own circle of friends and acquaintances. And we're sure you can find prominent examples in the business press no matter when you happen to be reading this.

Instead, plan for it. Make your entrepreneurially induced attention deficit disorder work for you.

THE FUTURE OF YOUR BUSINESS

Have you thought about the endgame? Do you have an exit plan? (We mentioned starting to think about this waaaay back in the Grind phase.)

As entrepreneurs, we often get so wrapped up in our short-term business goals that we forget to plan for the longer term. Here are your choices:

- You might get out of the business the hard way: you could go bust, either due to circumstances beyond your control or because you got fidgety as described above
- You could leave your business to an heir, i.e., your kids or some other designated heir
- You could sell your business, or you could continue running your business until retirement age and then decide what the heck you're going to do with it

- You could franchise the business and/or you
 could take the company public

You'll note these options are not mutually exclusive, and
not all of them are optimal either. Let's examine each of
them in turn.

Out of Business the Hard Way

Your chances of losing your business are never zero. The
economy could crash and take you with it. A natural
disaster or some other so-called "black swan" event (some-
thing big but highly improbable) might strike. Some star-
tups might make your whole market vanish overnight (look
up the history of Wikipedia vs. Encyclopedia Britannica).

Now is the time to ensure that you and your family are
thoroughly insulated against hard times, especially if you
haven't had the time to do this up until this point. This
means:

- Making sure your business and personal finances
 are *completely* separate. Ideally, they should have
 never been commingled in the first place
 (remember we said in the Startup phase to begin
 as you mean to carry on), but if things are still,
 ahem, messy, get them cleaned up fast. There
 should be separate bank accounts, separate credit
 cards, no dodgy loans or other in-and-out lines in
 the ledgers, and so on. You should do this to

protect your personal accounts in the case of business trouble, but also to be able to present clean books to a potential buyer, as we'll see below.

- Making sure your business and personal lives are *legally* separated as well. This is especially important to guard against losing absolutely everything if you get sued or end up in divorce proceedings. Again, we mentioned this in the Startup phase, but things might have gotten complicated as your business has grown. Tidy all of this up, as well.

- Start the college fund. We should have started this one much earlier, as it would have allowed us to maximize the federal government grants available for education. However, better late than never. You should prioritize education over your retirement because education expenses will come upon you way sooner than you think.

- Start that retirement fund. If you've got the kids taken care of, it's time to look after your golden years. Presumably, you've been taking a salary or a wage all this time in order to feed yourself and your dependents, but have you set money aside for your old age? Entrepreneurs typically don't because they can't at first, and then they forget to. You really don't want to have sacrificed a lot of your younger years only to end up eating cat food later.

We were fairly lucky in that respect. For years, we lived rather frugally, plowing money back into the business to make it grow. As the structure of the business changed, we started making contributions to the Canada pension fund through our salary, but had we not sold the business, those contributions wouldn't have amounted to as much as we would have liked. Essentially, we were (consciously) gambling on being able to take a bigger lump-sum payment and setting that aside when we sold the business. It worked, but it could easily have gone the other way.[4]

Leaving Your Business to an Heir

It's fairly common for businesses to be handed down from one generation to the next. It's also strangely common for the current generation to be completely opaque about how and when that's going to happen, and that's how things go sideways.

So, let's start with the basics. Do you have any heirs who are interested in the business? Don't assume! That kid you want to have follow you might have completely different interests, though hasn't been able to say so. They might also not have the right aptitudes for business. And that's okay! Not everyone wants to be as crazy as we are, and thank goodness for that.

If your kids are still young, it might be too early for them (or you) to say. In which case, now is the perfect time to talk openly about options, rather than letting silent expectations fill a communications gap.

Do you have more than one heir interested in the business? Again, don't assume. You might find that while one of your kids is open about their ambitions, another might be more circumspect. Talk to them and find out. If you have more than one, you'll have to judge whether they'd be able to work together or whether it might be better to sell up and let them share the cash to fund their own ventures instead. Many a business has foundered in the second generation because competing siblings tear it apart.

Once you've established interest, you'll need to ensure that they're given the resources and education to allow them to take over the business. Yes, if you've read the previous chapters and taken action on the advice, you should be able to hand over the operations manual(s), but you'll also want them to have practical, hands-on experience with you around as backup before handing them the keys and walking away. Even better, they should get an education and work experience *outside* the family firm before coming back. Before you can lead, you have to learn what it's like to follow.

Oh, and is your business something that *should* be handed down to the next generation? Consider the poor souls who inherited the family's blacksmith shop just as the first Model T cars were rolling of the lines. Thanks, Dad. Some businesses might be able to adapt to changing times or be timeless, others not so much. Don't saddle your heirs with a burden.

The ledger and legal cleanup we recommended above is critical here too. Sadly, nothing breaks up a family faster than money quarrels, and you want everything crystal clear and above board so that there's nothing to fight over.

Selling Your Business

You might have vague plans to sell the business ... someday.

The problem with *someday* is that it sneaks up on you. One day, you're in your mid-thirties and going gangbusters, and the next, you're approaching sixty-five and wondering whether it's time to retire.

Or maybe it has nothing to do with retirement per se; you just want a new challenge. Health issues (yours or someone in your family) might also compel you to leave the business.

Whatever your situation, the fact remains that you need to *plan* to sell your business. It doesn't just happen magically one day, and the act of selling your business isn't nearly as simple as, say, selling your house and car.

So how do you *plan* to sell?

1. You personally need to be separated from the business. Yes, you! Throughout this book, we've been saying that it's important for you to write down all the processes and procedures your business uses, such that you can hand over to someone else to run. This is both to make it a

better and easier business to run for all involved, and it means you can take time off when you need to. But *it's also important if you want to sell your company*. After all, if you're the linchpin of the entire operation, you'll never be able to escape! A buyer might be willing to take you on as an employee after the sale, and indeed, most business sales involve a transition period so that the new owners can consult the previous owners on day-to-day stuff with ease. But you'll probably want to make that transition period as short as possible. The new business owners are almost certainly going to be doing things differently, and you may or may not like how things change. Your staff will also need clarity on who the boss is, and you will want to move on to your next challenge. So, make it easy on yourself and make sure you have a business that's entirely and easily separable from you.

2. You need a very clean line of separation between *your* finances and the *business's* finances. You must be able to present a set of financials to a potential buyer that won't raise any eyebrows. We can't stress enough! At one point after we had sold Scribendi, we looked into buying into a couple of franchises, and later some non-franchised businesses. In each case, we liked the concepts and models powering the business enough to start toying with ideas for expansion

and so on. Yet when we finally got a chance to see the books in each of these companies, we were astonished at how messy they were, especially on the liability side. This was super frustrating and wasted everyone's time. A potential buyer shouldn't have to hire a forensic accountant to make sense of your financials!

3. You must also be able to separate the business from everything else you have, legally. Just like no one would want to buy a piece of land from you without knowing the exact boundaries, no one is going to want to buy a business where the assets are a tangled mess.

4. Get that file cabinet in order. Any proper business sale is going to include a phase called "due diligence." That's where the buyer gets to see ALL of your paperwork as well as having a look at your facilities. This includes your financials, any contracts you have with staff and suppliers, your manuals, your tax returns, the corporate minutes, any files connected with any previous legal proceedings, anything you've ever done about copyrights, patents, licenses, or trademarks, and so on.

5. You need to start doing things to get your business noticed. If you haven't applied for any awards yet, start doing so. The actual awards won't add heaps to the value of your business (apart from how they might sway customers), but the publicity you can drum up if you win one can bring your business

attention from potential investors. We started getting calls from private investment funds after getting a few awards. And find other reasons to start doing press releases, if that hasn't been part of your marketing mix to this point. The bigger your "footprint," the easier you'll be to find.

6. Bring everything up to date, and if your physical location and equipment is starting to show its age or is generally in need of a good cleaning, get moving. You should be keeping stuff up to snuff anyway, of course, as it's much better for staff morale and makes a good impression on customers. But it's understandable if you haven't noticed that your website is starting to look out of date or that the sign on the front of the building is askew. You've been busy! Fix that now.

7. Get a valuation. There's no point in dreaming of champagne and caviar if your business isn't going to net you as much as you might hope. You also don't want to undervalue your business to a prospective buyer, or worse, get laughed out of the room when you mention an absurdly high figure. Have an objective third party come in (preferably one familiar with your industry and current sales trends) to tell you what they think the business might sell for. Silicon Valley acquisitions aside, most businesses are priced based on what they earn times a number called a "multiple." That multiple will vary depending on your industry, how many other businesses there

are for sale in your industry, and what unique thing your business might have to offer that similar businesses don't have. Getting a valuation is a reality check; it might be painful. It might also let you know what you have to do to improve the valuation. Better to know ahead of time so you can maximize your return!

8. Actually put the business up for sale. If you're running something straightforward, like a locally owned and operated restaurant, this might be as simple as calling a real estate agent and your lawyer. If it's more complicated than that, you'll need to look for a firm that specializes in mergers and acquisitions. Shop around here; M&A firms vary in size from single-person offices to large entities with big staff complements. Find one you like (and that offers decent terms, usually commissions and expenses), and open a conversation. You'll be asked to help create a prospectus (a sales package to introduce your business to buyers), and then that gets sent out to buyers. This can be done without naming the business or otherwise letting the public know the company is for sale.

Then, you wait! With any luck, you'll find a buyer you like (both in terms of the money offered and whether you think they'll be a good fit for your business) and can start the long journey out of your business. We'll tackle this subject more

thoroughly in The Exit, but for now, remember this: don't jump at the first offer you get.

Even if you don't intend to sell, you may find yourself in a position where you're forced to. Rather than being unpleasantly surprised by all the work that's involved (and that has to be done all at once!) and badly shocked at the prices you get offered, *get all of those proverbial ducks in a row right now*.

Doing all the above will also put you in a position to consider ...

Franchising and/or Going Public

A full explanation of what's involved in either of these things is beyond the scope of this book (and will also vary from jurisdiction to jurisdiction), but we mention them here to point them out as options you might not have considered.

If you've developed awesome systems for doing what you do, and you're thinking of expanding into other locations, franchising might be a way to do so. You have all the benefits of an expansion with somewhat less risk to yourself as franchisees take on some of the risks of running a new location. It's also a way to become a national or international brand. If you've paid attention throughout this book and have carefully documented how to run your business, converting that into a franchise system should be relatively straightforward.

Franchising is not easy, however, as there are generally strict regulations on things like financial disclosure, your obligations to franchisees (and vice versa), the promises and claims you make about your business, and there might be major complications when you start operations in other areas.

For example, if you're a cleaning company with a proprietary formula floor cleaner, you may find you have to get it approved for use by local authorities in every jurisdiction you intend to franchise in. There are quite likely to be tax obligations as well, when you operate in other regions, on both the sales and income tax fronts. Intellectual property is also a concern: that great brand name you have in mind might already be taken, or worse, trademarked in the location you want to move into. Before you commit to franchising, do a thorough investigation of what might be involved *before* you start forking out money.

Going public—issuing stock and getting a listing on the stock market—might be a way to bring on new investors that will help you finance the next big step for your company. It might be a means to get news coverage and a bigger public relations footprint. The requirements for getting listed, however, will be onerous. You'll have a very long application process, be subject to strict auditing, reporting, and filing processes, and you'll have to be super careful about how you market your company. You'll also be beholden to customers, staff, *and* shareholders, and if you're careless about how much stock is issued and how things are structured, you might end up being one of those

CEOs that gets booted out of the company they founded. In other words, going public is not for the faint of heart. Again, do your due diligence and decide whether going public is going to meet your goals for the company and for yourself.

THE FUTURE OF YOU

And now for the most important consideration in the Happy Hill stage: what might be next for *you*?

Whether you intend to leave the business voluntarily or find yourself forced to leave it, it's a major life change. After all, this is something you've shed blood, sweat, and tears over, probably for years now. So like everything else we've discussed so far, it's something you should actively prepare for if you can.

While the business is happily chugging along, and you have some spare time and money, you should be rekindling old interests or cultivating new ones. And by this we mean more than just that half-finished knitting project you've been meaning to get back to for a while.

Hobbies should definitely be part of the mix, but let's face it: you're an *entrepreneur*. Realistically, you're not going to be happy just puttering about in your garden for more than, oh, five minutes or so (even if that sounds *really* appealing as you're reading this!). Remember, we generally want what we think we can't have. Once you get what you want, you'll probably be looking for the next horizon.

When we sold our company, we had a transition period built into the sale. This is fairly standard practice, and it was as much for the benefit of the new owners as it was for us. That phase-out allowed us to ease out of our business and into our new life, while at the same time, giving the new owners easy access to us for all those questions that come up more in daily operations than in any purchasing process.

Chandra finished up her transition phase earlier, as handing off daily ops and marketing was fairly straightforward. Terry's transition phase took longer as he was handing off IT management. Terry's expertise meant that a few people had to be hired to replace him, and it took time to get those staff up to speed.

We had a brief sabbatical period, where we kept our commitments to new things to a minimum. We weren't burnt out, necessarily, but the stress of negotiating the sale of the business, combined with some complicated elder care issues and a death in the family, certainly left us a bit crispy around the edges. We travelled a bit, attended to languishing house renovation projects, and tried to keep things as normal as possible for our children.

Once we started feeling restless again, Chandra plunged into a lifelong dream—getting a PhD. Terry took on the presidency of a national charity. Because we're entrepreneurs, darn it, and our Projects come with a capital P.

Apart from the fact that time heals most things, what made our transition tolerable was the fact that we'd been looking

beyond our business for a few years prior to the sale. Chandra had returned to volunteer work, first as a board member and then as a chair of the local library board. Terry had been involved with provincial and federal political associations for some time and had revived a long-term (and to Chandra, largely inexplicable) interest in model trains.

In other words, we developed our identities *beyond* the business. In the modern era, we define ourselves largely by what we *do*, and if we suddenly find ourselves *not doing* that thing anymore, it can have catastrophic effects on our sense of who we are and where we belong.

Even so, our transition wasn't painless. Although we were glad we didn't leap straight from business ownership into Our Next Big Thing (because it allowed us to properly relax and clear our heads so we could figure out what that was), it did leave us feeling out of sorts some days. Even when it's the right time to go, there is still a sense of loss that comes with parting ways with something on which you have lavished so much time and attention. You miss the job, you miss the people, and you will definitely miss that feeling of being in charge. We both found that we missed being in leadership positions.

So, now's the time to revisit old ambitions and goals, or come up with new ones, and to start pursuing them. If you're starting to feel panicky reading this because you're drawing a blank, try this: instead of trying to figure out what you want to *be* next, try thinking of it in terms of

what problem you want to try to *fix*. Think in terms of your personal development, your family, and your community. Or go big: regional or national level problems. If you leave this for the day *after* you give up your business, you risk making bad decisions or plunging into a depression that will be very hard to shake. So, think about it now. Circulate some ideas in your head at the very least.

THE FUTURE OF YOUR FAMILY

We'd be remiss if we didn't mention that other people need to be prepared for your transition too.

Whether you've been fully engaged parents or absentee parents, the fact that you're suddenly *more available* than ever before is going to take some getting used to. For everyone in the house.

If you've not been fully engaged, then your sudden availability is likely to be a source of friction. This is especially true if you show up with firm ideas about How Things Should Be Done Around Here. Your family already has habits and ways of doing things, and they're likely to resent your sudden appearance, especially if you try to change things that have been working quite well all this time, thank you very much. Your goal here should be to try to fit into the system as it exists and to see how you can contribute. Leave your big boss pants in the closet.

You also need to remember that just because you're on sabbatical or retired—or whatever you want to call it—the

rest of your family likely isn't. Your kids will still have homework, your life partner still has their career (assuming they weren't in business with you), and so on. Don't launch big projects involving your family without consulting them first! House renovations, travel plans, the next business venture ... everyone should be fully briefed and on board with the idea before you go disrupting everything. Indeed, before you even think of doing such a thing, you should consider *how you can play a supporting role in their lives* before anything else.

Especially if they have been supporting your dreams all this time.

The flip side of this is that you might need to brace yourself for an onslaught of requests for your time. Any local service group that hears that you're "retired" will reach out (new blood!), and extended family might suddenly have a lot of errands for you "now that you're not working anymore."[5] You'll need to find a balance between doing things to keep friends and family happy, finding time for the things you want to do, and actually enjoying some well-deserved time off. (Make sure you do get that time off!)

1. That and we're masochists who don't know how to quit when we're ahead.
2. As even as you can get if you have teens.
3. Entrepreneurs = never happy.
4. A potentially big risk for us was that artificial intelligence (AI) would advance far enough to completely reinvent the editing industry, but we didn't just hope it wouldn't happen on our watch. We

hedged our bets on that score by investing in AI research ourselves. Why be disrupted when you can do the disrupting?

5. This might even be the case even if you are actively involved in something new, because people can have funny ideas of what "work" means. It seems like, unless you're going to an office or a factory every day, nothing else counts as being busy!

Holy cannoli, you made it. You're ready to exit your business. With luck, you're doing so voluntarily and you're not being forced out for any reason.

If you've skipped the previous Happy Hill chapter to come straight here, we urge you to go back read that, as we, crucially, cover how to *prepare* for an exit there. In this section, we'll be talking about what the exit actually *feels* like and how to handle it. It is, just like every other aspect of running a business, a roller coaster experience.

THE FIRST SUITORS

Chances are, unless you have a super-unique business that is gushing cash (and, uh, are you sure you wanna sell that?), you're unlikely to be snapped up by the first potential buyer you meet. Prepare yourself now for a lot of time spent, hopes dashed, and no small amount of tension and frustration.

Your first brush with tantalizing possibilities may come from a realtor (if you're a local bricks and mortar style business) or from an investment fund (if you're bigger and/or more of a digital business). We started getting calls from private equity funds about seven years before we sold the company. Those first exploratory calls were mostly casual fishing expeditions; the caller would want to know if we were interested in selling anytime soon and what kind of revenues we were posting.

Be *careful* here. Don't be so flattered by the attention and dazzled by the prospects of selling that you give away important information. In fact, don't even answer right away! Before you return someone's call, do a bit of research on them. Are they part of a bona fide fund, M&A firm, or realty association? How long has this organization been around? Do they have any other acquisitions? And remember that it's not super hard to put up fancy-looking websites or online profiles; your contact might be a scammer, looking to do a bit of identity theft, or even a competitor, looking to get the inside baseball on what you're up to.

When you do return the call, ask them to tell you a bit about themselves and the firm they are representing. If that doesn't jibe with what you saw online or you get hard sell right off the bat, all kinds of red flags should go up.

We found it useful to ask the person on the other end what kinds of companies their firm would want to acquire and what size (revenue level). Quite often, it would turn out that what we had was some junior-level associate on the phone who had clearly been tasked with "finding some prospects" and who obviously hadn't done much research on who *we* were.

For example, we once got a call from a fund that invested exclusively in clothing e-commerce sites, and that definitely wasn't us. Finding that out early in the call saved both of us a lot of time. You'll be able to ring off politely by saying, "Ah, okay, well that's not us, we're in X industry and our revenues aren't at thirty million dollars yet." An added bonus of this approach was that it gave us an idea of where we had to be, financially, before we'd get serious and genuine interest in our company.

Another useful principle early on in the exit process is to try to negotiate from a position of strength. You really don't want to be so desperate to sell that you inadvertently give away company secrets (like the details of your main competitive advantage, for instance) or that you might settle for less than your company is worth. Or sell to the wrong people. Or all of the above. You should try to aim for

an opportunistic sale that allows you to get out on your terms—or darned close to them.

GETTING SERIOUS

If you get a truly interested party, and you feel like you're ready to sell (again, go back to Happy Hill to see the ducks you need to get into a row), you can move on to the next step, which is: cover your butt.

Your first step should be to get to know the potential buyer. Some questions to ask (or find out through deeper research) include:

1. What is your experience in our industry?
2. Why are you interested in this industry?
3. Why are you interested in our company specifically?
4. What are your goals for our company?

Why would you care about any of this? Well, if you're just looking to cash out, you might not care very much. But look into the future to be sure. Are you going to be happy to see your company swallowed by a faceless holding fund? Would you be okay with it if it was asset-stripped and sold off in pieces?

And what about your staff? It's their future you're holding in your hands, too. Are they likely to lose their jobs in the event of a sale? Obviously, a buyer is not going to be able

(or willing) to tell you everything they plan to do; they'll be concerned that you'll take their game plan and run with it. But you should be able to tell whether there's likely to be job security in the near to medium term. You will also want some comfort as to whether they'll be able to meet all the earn-out obligations of your deal.

There's also the issue of fit. If you're a small-to-medium business, the owner's personal style is going to have a big impact on the company. Staff used to being managed by an autocrat might struggle with a consensus builder, and even more so vice versa. You don't want your new owner to see staff leaving in droves either.

Before you reveal any substantial information to your buyer (and likely before they reveal much to you), get non-disclosure and confidentiality agreements in place. Don't stint on this; get a proper lawyer to draw one up that will guard against someone learning everything there is to know about your business and either starting up an identical one, telling someone else how to start one up, or just generally blabbing about your financials or other secrets to people who have no business in knowing. Better still, work with a proper M&A firm to help guide you through the experience.

Don't expect that this will make you bulletproof, though; there have been cases where a buyer deliberately breached these kinds of ingredients because they thought the risk and cost of court action was lower than the gains they

made from breaching. Be prepared for nasty surprises and to have to enforce these agreements in a court of law.

OUR OLD FRIENDS, STRESS AND MONEY CONCERNS

If you've gotten as far as signing an NDA, and perhaps even a letter of intent (LOI), get ready to be grilled like a cheese sandwich.

Your prospective buyer is going to want to know *absolutely everything* about your business: your financial statements back to when Adam was a pup; whether you've been involved in any legal action; what your intellectual property protections are; the records of all your employees (even the ones no longer actively with you); an incredibly detailed list of all your assets and liabilities; all the accounts you have (financial and online, and you will likely be stunned at how many accounts you've accumulated over the years); all of your processes and procedures; plans for the future; all your problems of the past.

We can't stress this enough: this is an *enormous* amount of work. Ginormous, even. It will consume weeks of person-hours. And you will have to do all of this work while also running your business and attending to your family.

At roughly this stage, at least some of your staff are going to be involved. Handling this well is critical.

For our first prospective buyer, who had contacted us out of the blue, we only told and involved a few senior staff, and we did so only because we had to (see ginormous,

above). We chose a few of our good people that we could trust to keep things confidential, and so for all the other people on staff, it was business as usual. We did this not out of any sense of secrecy but because there was no point in stressing everyone else out about a possible sale. At that stage, our potential buyer was serious but at the "kicking the tires and looking under the hood" stage.

As it turned out, our instincts were correct—nothing came of that due diligence process. The buyer ultimately decided it wasn't a good fit for him, and we parted ways amicably.

Having gotten that far down the possible sale path, though, we decided that instead of just waiting for new prospects, we'd actively put the company up for sale. We'd been in the business for twenty years, we were still young, and we wanted to be able to sell on our schedule, rather than potentially being forced to sell some years down the road or simply selling because we'd lost interest. As they say in show business, you want to be able to go out on top. It felt like the right time.

Our M&A firm helped us put together a prospectus and began showing it around to interested parties. They didn't use our real company name in this document, although if anyone from other editing companies had been shopping around at the time, it probably wouldn't have been hard to figure out who was being discussed. That is a risk you'll have to assume, too.

Eventually, we found a new potential buyer and went through the initial due diligence process again. This time, the buyer felt strongly enough about a sale to want site visits and even more information, and so it was time to break the news to the rest of the staff. We were as transparent as possible about it: why we were selling, to whom we might be selling, and we stressed that the deal might fall through at any time. Nothing was certain until the ink had dried.

The change in atmosphere was pretty much immediate. In general, everyone reacted well to the news, but there was palpable tension in the office thereafter. This was not surprising. After all, it was a big change for everyone, and in spite of our reassurances, everyone wonders about job security in situations like that. And they also worry whether they're going to like the new people, what the new standards are going to be, whether their job role is going to change ... Uncertainty is hard.

It was also hard on us. We felt tantalizingly close to realizing a pretty major goal—by this time, getting a payback on twenty years of slogging was feeling less like a want and more like a need—and we still had fairly young kids to look after (our oldest was twelve, our youngest was four) and homeschool. We were managing staff worries, our worries, trying to keep things on an even keel at home, dealing with Chandra's parents, keeping Terry's parents in the loop, and oh yes, keeping the business running as well. It was, in retrospect, as crazy as Startup life was—and just as hard on the nerves.

None of it came cheap either. There were the M&A firm's fees, the accounting and lawyer fees, all the hours of employee time spent, and the opportunity cost of not being able to push the business to the next level. The business wasn't stalled per se; it chugged merrily along because we'd set it up that way. But it did mean that any extra capital projects got put on hold. Not only did we not have the time or the focus, but you don't take on extra costs or incur new obligations in the middle of the deal. Effectively, everything was in limbo.

NEGOTIATIONS AND POST-SALE BLUES

Finally, finally, we got to the actual nitty-gritty of The Deal.

This, too, was super stressful. There was, as you might expect, a lot of back and forth on the price, when and how the money would be paid out, what the precise outline of assets was, working out non-compete agreements, and giving assurances on staff, ad infinitum. If you've ever negotiated for a house you really, really wanted, and there was a lot of craziness involved, you'll have some inkling of what it's like to sell your business.

Many coffee beans died in the making of this deal.

And then ... even though it seemed like it all took forever, it was over in a flash, and we were no longer business owners.

Even weirder still, almost overnight, we became ... almost guests in our own building. Don't get us wrong; the new

owners were lovely and never did anything to make us feel unwelcome. Quite the opposite, in fact. But you won't be able to help feeling slightly odd about the whole thing. It's no longer your show.

Inevitably, you also wonder afterward if you did the right thing. Did you get enough for the business? Are your people going to be okay? Part of that is the natural second-guessing process people go through after big decisions, and part of that is the post-deal adrenaline let down. We suspect it's somewhat easier on the buyers because they have a shiny new toy to play with, a *lot* of new stuff to learn, and a big bill to pay, to boot.

It was even harder to watch our staff adjust. The new owners had their own style, and it took some staff longer to adjust to that than others. You worry. Eventually, though, there's a new normal. We had decided early on that we wouldn't stay around for a moment longer than necessary, for everyone's sake. We needed to adjust to our new lives sooner rather than later, the new owners needed to be able to get on with running the business without feeling like we were looking over their shoulders, and the staff needed the clarity of having just one boss.

Or in other words, you'll allow your staff (and yourself) to get to the new normal faster if you have the bare minimum transition period. Don't linger!

AND NOW … NEW HORIZONS

We've come a very long way from those days in Startup. We're older, and so are our children, and Life with a capital L keeps happening.

We can't advise you on what to do next: that will be down to your own interests and abilities, your health, and whatever obligations you might have. A lot will depend on the circumstances you find yourself in too. It may take you a few months or more to figure out your next steps. Don't rush it, but don't let yourself founder either. You're an entrepreneur, and you're at your best when you're pushing yourself and punching above your weight.

Our own thematic focus since that first major business has been on helping people and communities build resilience. That's why we wrote this book and founded the small press that published it. Our fiction is designed to help people envision the futures they want, and our nonfiction helps people figure out how to get there.

Our other projects at the time of writing include a board games café and independent bookstore (to strengthen our community and increase access to knowledge), backing affordable housing projects, organizing people around environmental issues, and improving public transit in our province and our country. Indeed, being able to do this sort of thing now is one of the primary reasons we went into business in the first place: to be able to make a dent in the universe.

It feels good.

Whatever you end up doing, we wish you well. And we'd love to hear about it. Please feel free to drop by our website, leave a comment or a message, and talk about your business ups and downs with your fellow entrepreneurs.

WE'VE WORKED VERY hard to make this book a resource that will save you time, money, and a ton of heartache. In addition to enduring the nearly twenty years of hard knocks to earn the wisdom we've tried to impart here, we invested a lot of time and money into making this book the best it could be.

We did this because we firmly believe that the freedom a responsible entrepreneurial lifestyle offers is key to advancing the health and prosperity of large segments of society in the future. We did it for our kids, and your kids too.

So help us spread the message. If you found this book helpful, please consider:

1. Leaving an honest review on places like Amazon or Chapters

2. Gifting the book to friends or family
3. Mentioning the book on your blog or social media
4. Bringing the book to the attention of your mastermind or forum, local chamber of commerce, or business improvement association. Or for that matter, any other organization that serves entrepreneurs! Special discounts are available on quantity purchases by corporations, associations, and others. Contact customerservice@tigermaplepress.com for details.
5. Doing all the above!

Thank you so much!

Oh, and one other thing. As you progress through your entrepreneurial and family journey, don't forget to pay it forward. Pass your unique learnings on to other entrepreneurs. A rising tide lifts all boats!

All the best,

Chandra & Terry

ACKNOWLEDGMENTS

This book, and obviously our entrepreneurial success, would not have been possible without the help of the wonderful people at Scribendi. Thank you so very much. Yes, we did have this book edited by Scribendi. Any typos or grammar gaffes in the text are our own, cleverly introduced by us afterward, as we continued to tinker with the manuscript. Our thanks to all the entrepreneurial parents we have talked to over the years. Your willingness to share your war stories and vulnerabilities is what inspired us to write this book. Thanks also to our beta readers and early reviewers. Your comments and suggestions were invaluable.Finally, thanks to everyone involved in the production and marketing of this book. A lot of time and effort goes into this kind of project, and we couldn't have done it without you.

ALSO BY CHANDRA CLARKE

Echoes of Another - A Novel of the Near Future

Pundragon - A Humorous Fantasy

Made in United States
Orlando, FL
06 December 2022

25668137R00127